NOAH'S TURN

KEN FINKLEMAN

NOAH'S TURN

A NOVEL

HarperCollins*PublishersLtd*

Published by HarperCollins Publishers Ltd.

First edition

HarperCollins Publishers Ltd
2 Bloor Steet East, 20th Floor
Toronto, Ontario, Canada
M4W 1A8

www.harpercollins.ca

The author would like to acknowledge the poem
"The Black Swan" by James Merrill, which inspired the
description of the swans on page 7.

Library and Archives Canada Cataloguing in Publication

Finkleman, Ken
Noah's turn / Ken Finkleman.

ISBN 978-1-55468-752-7

I. Title.
PS8611.I64N62 2010 C813'.6 C2010-900508-2

Printed and bound in the United States
RRD 9 8 7 6 5 4 3 2 1

For Sidney, Abe and Marion

Noah Douglas was not a nostalgic person in the sense that he longed for a certain time or event in his past, but he did long for something that now, at forty-one, was long gone. He longed for that state of mind which spanned the years between his first joint in junior high school and the day of his marriage at twenty-eight, that state of mind which knew nothing of ambition, or goals, or the striving for respect. He longed for those glorious years when each morning, no matter what had transpired the night before, was a new day. Noah longed for unconsciousness.

1

Travels with His Aunt

They had no children, so the divorce came down to dividing up their assets. Because Noah had always believed his wife was a more sensible and truthful person, he accepted her judgment on all domestic issues and he accepted her claim that he had ruined her life because she was now thirty-eight and beyond her prime child-bearing years. The guilt he felt for this crime resulted in her getting most everything of value, which included their circle of friends.

———◆———

It was a cold March morning when Noah left the cheap second-floor apartment he had rented above a Starbucks

after leaving his wife with the house. This was his weekly walk to visit his aunt, who was dying of cancer. She was the last of the family with "real" money and lived in an exclusive enclave about a half-hour away. He made these trips for two reasons: one was a sense of charity, which was more family tradition than good intention, and the other was to support his shot at a piece of the inheritance his Uncle Cotty had left three years earlier after a massive brain hemorrhage on the Pinehurst Country Club's ninth hole, which was subsequently renamed Cotty's Corner. Noah got drunk at the funeral, and when comments about the deceased were solicited, he volunteered that the club had managed to exclude Jews but couldn't keep Death from teeing off. Since then he had worried that he might be cut out of the will entirely.

Noah jammed his gloved hands into the pockets of his twenty-five-year-old navy blue cashmere topcoat, which did little to protect him on a day like this. The coat had been a gift from his parents on his twenty-first birthday. Between its remaining patches of deep navy richness and the frayed sleeves, faded elbows and shredded satin lining, you could pretty well trace the financial record of Noah's adult life. As he liked to say about

old money, "The first generation makes it, the second drinks it up and the third has to work for a fucking living." Noah was the third. He came out of Queen's University in 1990 with a master's in philosophy and ended up a staff writer on a TV cop show, an occupation the extended family couldn't quite grasp.

"What are you doing these days, Noah?"

"Writing."

"A book?"

"TV."

"You mean television?"

"Yes."

It seemed he'd repeated this conversation a hundred times in one form or another at family events, which, mercifully, in recent years had been reduced to Christmas dinners and funerals.

"TV?"

"Yes."

"Television?"

"Yes."

He pushed through the headwind that felt like a bottle of vodka from the freezer pressed against his face. His ex-wife would be proud of him, he thought, going out on a day like this for money.

He passed a street person bundled in all his or her possessions, sleeping on a sidewalk heating grate. A dead duck, he figured, if it stayed this cold overnight. But then, "Everyone has his own battle." Noah had never forgotten this remark made by one of his philosophy professors, and it gave him some comfort as he left the homeless person behind. "I should have worn long underwear, for Christ's sake."

But he hadn't owned a pair since the sixth grade at Chesterton, the boarding school where, he enjoyed reminding his relatives, he had exorcized his latent homosexuality. He wondered where his long johns were now. He wondered where all the other stuff had gone too: the model WWII destroyer, the planes, the board games, the Bond novels, the bolt-action .22, his Rawlings glove, the essays, his desk and chair, the fishing gear, snorkel and fins. Do they end up sunk to the bottom of some vast swamp of childhood things? The graveyard of happiness. Almost everything was gone.

He passed through the entrance to his aunt's enclave. Two stone pillars connected by an ornate wrought-iron span straddled the road. There was no locked gate or guard to hold back the undesirables. This handful of grand houses had been built at a time when the mere

symbol of wealth was enough to repel the unwashed. He passed the single clay tennis court, maintained by the community's grounds committee, and circled the frozen pond where two white swans mysteriously appeared every spring and glided like slow-moving question marks until they mysteriously disappeared in the fall. We have swans, Noah thought whenever he saw them, and this reassured his sense of entitlement even though he himself was always close to broke.

The door opened and there stood Jeanne, his aunt's Jamaican live-in. She wore a tight-fitting nurse's outfit. Her face lit up with an expansive grin that was both seductive and motherly. Everything about Jeanne was expansive—her grin, her lips, her hands, her hips, her feet, her ass, her tits.

"How are you, Mr. Noah?"

"Fine, fine."

He stepped in and wondered if "Mr. Noah" was a typical Jamaican expression just like the big grin or whether both were some sardonic comment on this sinister cliché—black servant, white boss. Or maybe she was simply who she appeared to be, a devoted caregiver with a generous smile. Or maybe not. This is how Noah's mind worked. Nothing was simple. And at times it exhausted him.

"Let me take your coat."

Noah wriggled out of his backpack and from it pulled a bottle of Bombay Sapphire gin, a bottle of Schweppes tonic water and two lemons, then handed Jeanne his coat.

"Gin and tonic," she laughed. "Auntie and me are going to have a good time this afternoon."

Noah laughed and wondered how much of what he usually brought was consumed by Jeanne. He knew his aunt still liked her gin and tonic, and he felt proud of what was perhaps her remaining laudable quality: she was still a drunk. He imagined how much better a funeral it would be if she staggered and fell dead drunk into her grave rather than being lowered with all the phony elegiac reverence that was sure to come.

Jeanne examined his coat's tattered lining. "If you stay for a while, I can fix this for you."

"No, no. Thank you. I have a guy, a small place on my corner, a tailor and laundry. He says the whole lining has to be replaced. I'm taking it in this week." He had no intention of taking his coat anywhere because it wasn't the kind of thing he did.

"How's my aunt?"

"Just fine. Doing very good."

Noah nodded and smiled and thought, Why couldn't she say just once, "Auntie's dead, Mr. Noah. There's two million in cash for you on the dining-room table"?

"I'm making her favourite black bean soup. She loves it, but I don't let her eat too much because it gives her gas. Why don't you go up? Try to be quiet, she's sleeping."

Noah went up to the bedroom where his aunt lay sleeping on her back. He settled into the visitor's chair. Her remaining mass barely left an impression under the smoothly tucked covers, and he imagined that with her head lopped off it would look like a freshly made empty bed.

Noah's thinking tended to circle the morbid like a buzzard over a carcass, and there was little else to do in the room during these visits while she slept except think about death. He could smell the bean soup Jeanne was cooking downstairs and wondered if it would give his aunt gas. Perhaps enough gas to kill her with one humongous fart.

His aunt's emaciated body and this line of speculation regarding deadly gases made Noah think of the Zyklon B gas used by the Nazis in the gas chambers. He remembered an anecdote about Zyklon B he had read years before in a book titled *The Crime and*

Punishment of I.G. Farben. The gas had been developed by Farben, a German conglomerate of three chemical companies: Bayer, Hoechst Pharmaceuticals and BASF. When Zyklon B was released into the gas chambers at Birkenau, the extermination camp attached to Auschwitz, its odour would spread through the outer compound. The prisoners would recognize the smell, panic and sometimes riot. However, the odour was unrelated to the gas's efficacy. It was a safety feature, an indicator that the toxic colourless, tasteless and odourless gas was present. Annoyed by the disruption the odour caused among the doomed prisoners, the camp commander demanded that it be removed. Farben refused. The only feature of the gas they controlled under patent was the odour indicator. If it were removed, the market for the extermination of Jews with gas would be open to competition from other companies. This business fight went to the highest levels of the Nazi command, and Farben, with its size and influence, won the day. The odour stayed, the mass murder continued and Farben's contract was secure. This story was, for Noah, the defining myth of capitalist consciousness: devoid of religious, moral or legal constraints, capitalism ends up at Auschwitz. And just as his aunt's near-skeletal form was

beginning to recall for Noah the more horrific photos from the Holocaust, she opened her eyes.

His aunt stared at him without changing her lifeless expression. He was sure she didn't recognize him. "She probably thinks I'm one of her useless sons, who are right now waiting in London and New York for her to croak before they fly in to scoop up the cash."

"It's Noah, Aunt Helen, Audrey's boy." He smiled. Nothing. The whole ritual seemed senseless to him. If she hadn't already included him in the will, she certainly wasn't in any condition to change it now.

"It's incredibly cold out there. I walked."

Then, as if from a brain stashed in a drawer by the bed, she spoke. "Walking is good for you."

"Yes, yes, you're right. How about the will, am I in or out?" The question was left unstated.

She closed her eyes.

He quietly left the room and met Jeanne at the front door.

"This soup is for you. We've got too much."

Jeanne handed him a Tupperware container of hot bean soup.

"You better not put it in your pack in case the top comes off."

"Thanks, very generous, thank you," he muttered as he got into his coat and his pack.

Jeanne picked up a glass of water and a bottle of pills from the hall table. "I have to give Auntie her pain medication."

"What's the prescription?" Noah tried to sound medical as he eyed the bulging bottle of fat white pills.

"Per-co-cet," Jeanne said reading the label.

"Mmhm," Noah responded, as if to give his medical approval. He wanted to ask her to save them for him when his aunt died but at the moment couldn't summon the courage. "See you next week."

"Auntie always likes it when you come. And so do I."

Hold on to those babies, I'll be back, he thought as he stepped out into the cold. Noah picked up on Jeanne's "And so do I," but only as much as something that flashes in and out of one's field of vision so quickly that its form can't be discerned.

The wind was at Noah's back on the way home, and most of the route was downhill. His Christian work was done for another week. He held the soup in front of him,

cupped in his hands like a religious offering, and could feel its heat through his gloves. The memory of its aroma now made him hungry. He couldn't wait to get home and when he stopped at a light, he popped the lid and took three deep gulps. "Good soup," he muttered. He snapped the lid back on and kept going. He remembered one of the endless maxims that guided his mother's drunken, beautiful, spiteful, dramatic life as a "belle of Anglo society," and that was, "The ability to delay our gratification, Noah, is what sets us apart from the other classes." Soup without a spoon on a street corner—how the mighty had fallen! It was not just his uncontrolled hunger, but his monosyllabic appreciation, "Good soup." Just flip that, he thought, to "soup good," and he's not only a fallen upper-class WASP but some atavistic fucking caveman.

Noah now remembered, when he was small, sitting beside his mother watching *The Flintstones* and asking, "What if we were cavemen?" She said they were not cavemen, even if two Catholics had managed to marry their way into the family. He liked his mother's answers to his questions even though he didn't always understand them. She didn't talk to him as a child. She was sarcastic and funny and self-centred and he wanted to be like her when he grew up.

She usually had a drink in her hand when she watched TV, and when she sat right beside him he could smell the Scotch and the odour of cigarettes on her silk shirts. Her drink always made him feel secure because he knew she wouldn't jump up and do other stuff when she had one. It eventually killed her.

He reached his street and stood over the homeless bundle on the heating grate. He looked down at the woman's face, a fleshy circle framed by scarves and blankets. There was something peaceful about it. Not drunk or crazy. It was old, and Noah guessed Inuit. Her lips were clamped together in a horizontal, toothless pucker. He placed the container of soup beside her and nudged the bundle with his boot toe. "Are you sleeping?" Her eyes opened without focusing. He handed her a twenty-dollar bill. "Here." She pulled a bare hand from between her knees and took it. She folded the bill and put it into a pocket without changing her expression or saying a word. Noah pointed at the container. "That's some soup. It's very good. Homemade." Her eyes closed and she went back to sleep or to wherever she had been before his interruption.

As he waited for his cappuccino at the Starbucks below his apartment, Noah thought that the homeless

woman would not likely spend the twenty dollars today because it would mean leaving the grate and perhaps losing it to someone else. In this weather that could kill her, he thought. And he realized how far one can slip from the world most of us take for granted.

2

McEwen

When he stepped into his apartment Noah listened to his messages before removing his coat and boots. One call from McEwen. "It's Patrick. I know we're scheduled for lunch tomorrow at The Senator but I just got swamped with a horrible week. People from everywhere all over me. Can we make it next Tuesday, same time and place? Give me a break on this one. No need to confirm. If I don't hear from you I'll assume this is okay. See you then."

Noah kicked off his boots and dropped his coat on the floor. He was home with no one to answer to, no questions about his work or personal habits or divorce. He thought of it as the wonderful dead zone. He took a beer from the fridge and dropped onto the couch. He

didn't want to but couldn't resist a masochistic need to listen to McEwen's message again. Just to confirm a few deconstructionist points. "A horrible week" was not a complaint but a McEwen swagger. It meant a week with every minute devoted to something important. Unlike Noah's normal week, which dribbled away like a leaking faucet he had no energy to repair. "People from everywhere all over me." Far from the pestering annoyance it described, this measured the currency of McEwen's reputation and demand. "Give me a break on this one" was the most insidious of all. The dominant party, McEwen, with disingenuous magnanimity, transfers authority to the lesser party, Noah. An image came to Noah of someone playing with his dog in the park. The dog owner realizes he is late for a meeting and, scratching his dog under the chin, scolds him in mock anger. "Look what you've done! You've made me late for my meeting!" The authority is transferred to the dog—to Noah. And finally, "No need to confirm. If I don't hear from you I'll assume this is okay." McEwen establishes who is really in charge.

"Fuck him."

He timed his arrival at The Senator late enough to ensure that McEwen would already be there but not so late as to piss him off.

McEwen wasn't there. Noah took a booth and was about to take his laptop from his bag when he realized that he'd look like every other hopeless schmuck tapping away at Starbucks and faking a life. Instead he pulled out a newspaper just as McEwen walked through the door.

"Sorry. I got hung up. I had a crazy morning." He reached for Noah's hand. "How are you?"

"I'm jerking off under the table. I'll just be a second," Noah wanted to say, but then pulled his hand up from his lap and shook. "I should be working out more."

"Then we have to play some squash," McEwen insisted as if he was concerned for Noah's well-being.

"Any time you want."

"Call me. We'll set it up." McEwen knew exactly how to get the ball back. "How's Nora doing? These divorces are always tough."

"She died."

McEwen's face dropped for half a second before Noah continued. "Joking. She has the house, how bad can she be."

"That was a great gesture on your part. No lawyers, no battles. You just gave her the house. I told Spencer, whose firm does a lot of high-end family law. He said you were a real pussy."

"You are what you eat."

"Oh, yeah."

Oh, yeah? Noah repeated to himself. Fucker can't give me credit for the joke?

Noah shook his head in agreement. To what he wasn't quite sure. It was some kind of sycophantic tic that McEwen brought out in him. "Nora's a good person. She knows how to live in a house and do things with dishes and linens and changing light bulbs. I'm more at home in a cardboard box on the street."

Noah knew that the way to hold McEwen's attention was to assume the lesser position, and he needed his attention today. But McEwen would never go for a nose right up his ass. That would be too complicit in low-life gamesmanship. Only subtle grovelling would work—self-deprecating humour that acknowledged McEwen's superiority. After all, McEwen had achieved a certain prominence both among the local literati and in the world of academe, and to be friends with this person he hated put Noah within reach of a world he coveted.

Unfortunately, the resulting relationship left him with a self-loathing that festered like a drug-resistant infection.

Noah knew that what attracted McEwen to him was strictly genealogical jealousy. Noah was from old money, to the manor born, and McEwen was working-class Irish. But as much as Noah could claim the class advantage, McEwen held the power. Noah was aware that social class, amongst the intelligentsia, could be easily dismissed, especially if the money was long gone, but reputation was everything. McEwen had reputation and Noah didn't.

McEwen's professional life, like the sound of his name, was all angles. He was an editor at a publishing house, which helped him get a book of short stories published, which landed him a position teaching creative writing at U of T (which assured him the weekly rapt attention of half a dozen nineteen-year-old co-eds with perfect breasts and silky inner thighs), which led to regular contributions to one of North America's top book-review journals. Unlike his angular name, his body was round and on the short side. He often wore a bow tie, which seemed to say, "I *can* wear a bow tie," rather than "I am wearing a bow tie." When he dressed for squash, he pulled his white socks up over his bulbous

calves just below his stubby knees and wore one of those ridiculous white tennis sweaters with a blue V-neck over a chubby belly.

As much as McEwen tried to dress his way out of his inherited position, Noah could spot the class character-istics that gave him away. Such as his marriage to Janice Hogan, a short, small-town Catholic with big tits and the social instincts of a Rottweiler, which had helped her chew her way to the position of editor-in-chief at the city's major lifestyle magazine. Although it took, as Noah said, the attention span of a gerbil to read through an issue, she was still able, in his opinion, to dumb it down considerably.

The waiter arrived. Noah ordered the burger, frites and a Coke and offered, uncontrollably, "This one's on me." At which point he was sure that McEwen shifted his gaze to the more expensive section of the menu, from which he ordered the black cod and endive salad. "And I think a glass of this white." The waiter picked up the menus and left. McEwen leaned slightly to Noah. "Can I pick up the wine? It's not a cheap glass." Noah had a name for this question. He had coined it while dating a high-maintenance girlfriend who used it fre-quently. It was "the double reverse." The double reverse

was an offer of generosity that put the other person in a money-grubbing position if he accepted it. "Don't be silly, it's all mine," Noah said with a smile. "Where's the novel at?" he continued with as much enthusiasm as he could muster after being nailed with the cheque.

"I should have the second set of notes from my editor finished on the weekend. They love it. They think it's going to be huge. But that's the publisher. They talk like that. I should know, I'm one of them. They are in the business of selling books." Noah could read McEwen. He had tossed this off to mean the publisher's gushing adoration somehow compromised his own creative integrity with commercial taint while also including himself in the lofty brotherhood. McEwen had to have it all. "I'd like you to read it."

"Jesus, that would be fantastic, a real honour," Noah blurted out, even though he knew that burning the book would be a more positive cultural act. How could I have said "honour"? he thought. What a fucking obvious blowjob!

McEwen swallowed the first bite of his cod and sipped his wine. His measured action was an almost balletic counterpoint to Noah's fumbling envy. "And your TV show?" McEwen asked without looking up.

"Same old shit. Cops screaming, 'On your face! On the ground!' It's pulling teeth. I can't do it anymore. It's fucking soul-destroying." Noah bit into his loaded burger, squeezing out its condiments, which ran down the inside of his left hand toward the entrance to his sleeve. McEwen took another sip of wine and said nothing as Noah caught the mustard-and-ketchup stream with his napkin. They continued to eat in silence for a minute, which seemed like an hour to Noah. His brain felt paralyzed, unable to come up with something interesting to say or at least something McEwen would respond to without a disinterested shrug. Noah could feel drops of sweat form in his armpits then slide down his sides under his shirt, where he picked them off with quick elbow jabs. Was McEwen testing him to see how long he could hold out in silence? Noah put his burger down, straightened up and wiped his mouth with his napkin. Was that too much physical punctuation for what was to come? He had planned to let it slip out in conversation but the conversation had stopped.

"I wanted to ask you a small favour."

"Shoot."

McEwen's quick response caught Noah off guard. He clumsily started digging through his backpack

as he cranked out gratuitous apologies for noth ng. Noah hated McEwen for the response he was able to elicit without even looking up from his plate. But he hated himself more for hating McEwen, someone who should mean absolutely nothing to him. "I'm sorry to spring this on you at lunch without any notice. I should have told you why I wanted to meet, but this sort of thing makes me nervous and . . . I put it in here . . . and I . . ."

"What is it?"

"I'm sorry."

"For what?"

"Nothing." Noah's hands were trembling as he pulled an 8 × 11 brown envelope from his bag and put it on the table.

"This could be crazy, but that's an outline for a novel. I mean . . . I know how hard it is to get a novel . . . I thought you might have one of your editors take a look at it. I don't want you to . . . I mean, I'd love it if you also read it . . . but that might be a conflict of interest. Or not." Noah smiled, thinking he had salvaged something with this last slightly glib remark.

McEwen fingered the envelope without saying a word. Then just as his lazy gesture was beginning to

look to Noah like a cliché out of a Hollywood movie, McEwen looked up and said, "A novel."

"You don't have to." Another one of Noah's intractable projectiles that shot out from God knows where in his psyche. No matter what transpired between these two, Noah would never overcome his beta male role.

"Do you know the name Hobson? Very rich, I think." McEwen changed the subject without any reaction to Noah's offer to let him off the hook and this left Noah feeling rudderless in the new conversational current.

"Peter Hobson?"

"Could be."

"If he runs a hedge fund, I think my cousin knows him."

"That sounds right."

"He's supposed to be a prick." Noah could only think one thought now: "Let's get back to the outline, fucker."

"His daughter's in my creative writing class. Incredibly gorgeous and smarter than both of us together. It's driving me crazy. Don't say anything."

"Never. No, no. Have you got a little something . . ."

"God, no. I'd never touch that. They not only fire you, they jail you for that shit these days."

"I have a seventy-five-year-old bag lady sleeping on the sidewalk in front of my apartment. Same problem— almost." Noah was trying to think of a way back to the outline when McEwen smiled at the joke and Noah's suppressed rage softened. But when he picked up the cheque without a hint of resistance from McEwen his resentment again flared.

McEwen continued to extol The Hobson Girl's virtues, without addressing the fate of the outline, until the waiter returned with the credit-card receipt for Noah to sign and the two men stood to leave. McEwen picked up the envelope with the outline inside and tucked it under his arm. Mission accomplished.

3

Body of Work

It was mid-2008 and the world economy was in a tailspin. The problem was called a "credit freeze," and experts tossed the term around like they knew what they were talking about, when in fact no one really knew what had happened or where it was going or how to fix it. TV, that perennial cash cow, was not immune. Advertising dollars were drying up at record rates and networks were facing possible bankruptcy. "Downsizing" swept through the industry to "restore economic health," which meant firing large numbers of people lower down to save the fortunes of a few higher up. On the show that employed Noah, the first to go were the unionized writers. There was an unstated understanding that anyone could write this crap. You could pay a guy to cannibalize old scripts.

change names, juggle scenes and come up with something that sounded new. Noah was not the most enthusiastic and hard-working member of his staff and was one of the first to go. There was little he could do about his situation given the financial climate, and besides, he lacked the energy to fight for a job in which he had lost all interest. He could not fathom the concept of any other kind of permanent employment, was ill-suited for office work and refused to contribute to the corruption of "the word" by using it to sell, market or advertise anything. He had once, at his wife's urging, seen a corporate headhunter, whose not completely facetious response to Noah's bio and so-called ambitions was that his only mistake had been to not marry money.

So Noah decided to start visiting his aunt twice a week.

"Your auntie just fell asleep. Let me make you a cup of hot tea."

Jeanne took Noah's coat and noticed the lining was still in tatters.

"I didn't have a chance to get it in, but I'm taking it to my guy on the weekend."

They drank tea without saying much. Just a few feigned compliments for Noah's aunt, who had been quite the racist bitch in her prime.

After a minute or two of slightly awkward silence, Noah rubbed his temples with his fingertips. "I've been having horrible headaches the last few days. I think they're migraines."

"That's not good," Jeanne said with a genuine look of concern.

"I was thinking, my aunt's painkillers—she couldn't spare half a dozen or so, could she?"

Jeanne stood up. "Of course. She doesn't need the doctor when they run out. I call the pharmacy and walk over and pick them up." Jeanne left the room.

"Terminal cancer has its upside," Noah thought. Two Percocets with a glass of good scotch was just what he needed. His aunt was a strict gin drinker, but his uncle had been a serious scotch man, and Noah knew there was still lots of it kicking around. He went to the dining room and pulled half a bottle of ten-year-old Macallam from a sideboard, poured a glassful, took a quick glug from the bottle, put it back and returned to the kitchen with his glass just as Jeanne came through the other door.

"My uncle's scotch. People say it's good for migraines."

"I'm not so sure of that," Jeanne said as she put six Percocets into a sandwich bag and handed it to him. "You

be careful with these, specially with alcohol," she said, touching his upper arm. This contact felt very strange to Noah, out of place but at the same time genuine.

Jeanne turned to the counter and poured more tea while Noah quickly, without her seeing, swallowed two pills with a big swig of scotch and stuffed the baggie into his pocket. Jeanne turned around and rested back against the counter with her tea cupped in her hands. Noah could sense that something was going on but he wasn't sure what until Jeanne smiled and dropped her look to the floor.

"Would you like to come into my room? Auntie won't be up for hours and my room belongs to me when the door is closed. What I do in there is private. A person who is live-in needs her own place."

"Holy Christ," Noah thought. That was without a doubt the horniest thing he'd heard in years. The scotch had already hit him hard and he suspected the Percocets were bubbling into his blood as well. He was not the type who got propositioned by women. In fact, no woman had ever propositioned him. He had always led in his past mating dances, with varying degrees of success.

Noah felt engulfed by her body, inundated by a force of nature. He remembered as a kid being swept

away by the undertow in Palm Beach and his mother fighting like a maniac through the ocean's power, a person who wasn't going to take shit from the forces of nature when it came to her boy. Thank God his mother wasn't here now, and he let himself be pulled under and dragged away. Jeanne moved up and down on top of him and whispered, "Grab my ass. Put your fingers in my ass." Noah had never heard this from any other woman. He struggled to hold back his orgasm. To come too fast would appear like common racial exploitation and he wasn't going to reduce this to that. This was too good.

Jeanne handed Noah his coat at the door. They said nothing about the sex.

"I'll see you soon. Be careful with those pills," she said, holding the door open.

"Yes, yes. I will. Thank you."

Jeanne closed the door.

———

On Noah's next visit the sex with Jeanne got better. His aunt again slept through the whole thing, even though Jeanne's bed's legs screamed across the hardwood floor.

The following visit his aunt was awake the whole time. There was no sex but he was able to have a conversation with her during which she mistook him for one of her sons. On another visit, just two days later, Noah's sexual hunger had him running half the way there. An attractive Asian nurse answered the door. "Jeanne isn't here today. I'm filling in for her." Noah, deflated, stepped in and took off his coat.

"But she's coming back," Noah said. "This is only today."

"Yes. She's at the doctor."

"The doctor?" Noah repeated nervously. "Is she okay?" The Asian nurse had missed this. She had taken his coat into the other room and left him alone in the foyer. "The doctor," he muttered again. He started pacing, turning the phrase over in his head. Two short steps, turn, another two steps, turn. Noah was the type who could lose sense of his own physical actions when a wave of anxiety rolled in. "The doctor. What if she has AIDS?" His mind started tumbling. He had to get out of there. He scrambled to find his coat like a balloon that had been inflated, left untied and let go to careen around the house.

The Asian nurse reappeared. "Jeanne is getting wisdom teeth removed."

Noah stopped dead. "Wisdom teeth?"

"Yes, sir. Would you like something to drink—water or a juice?"

Noah didn't hear a word of the offer. He took a deep breath, pushed a hand through his hair and started to jabber about wisdom teeth and dentists and dental plans for the poor as he poured himself a celebratory scotch from the dining-room sideboard. He then virtually soft-shoed it up the stairs to his aunt's room where she was sleeping. He took two Percocets from the bottle next to her bed and downed them with a single gulp that finished off the Macallan. He pocketed six more pills, kissed the paper-thin skin of his aunt's forehead and headed back down wondering if maybe, just maybe, Jeanne had given her "cute little Asian replacement" instructions to have sex with him. When he saw her waiting in the foyer, hands clasped in front of her, a sweet smile on her innocent face, he came to his senses, told her his number was on a card taped to the fridge door and asked her to call if there were any problems.

"That's very good of you. I'm sure we'll be okay. Thank you."

He wanted to grab her and pull off her white uniform and panties and bra and swallow her small breasts

and lick down her stomach to her tight black fluff vagina and drive his mouth deep into her ass and he knew if he started she wouldn't resist but would join in this bicultural explosion of lust. "Anything you need?" he offered.

"No, I think we'll be fine, sir."

He pulled on his coat and left.

4

Blogged to Death

Noah got a phone message from Patrick McEwen's wife, Janice, asking him for lunch Friday. She wanted to talk business. That was all. No other details. When he got to the restaurant she was already sitting over a glass of white wine and her BlackBerry. She wore a crisp white shirt with a starched collar that flared up like the sartorial wings of the Flying Nun. This was more to conceal her neck than to take flight. Noah thought she wore too much jewellery to get airborne anyway. She was one of those women with rings on at least eight of her fingers, including one thumb, which Noah found aggressively non-sexual. Too many things could be snagged during sex. And if she took them off before sex, the whole procedure would be far too mechanical and premeditated.

When he sat down, Janice immediately took charge. She put her BlackBerry away and ordered him the same wine she was drinking and an appetizer for the table. There were no children to discuss on either side so she got down to business. "I know they dropped you and some other writers from your show but the networks are getting killed out there. We're also feeling it at the magazine—part of it is shrinking ad revenue, part the readership's move away from print to online. We figured that the best defence is a good offence, so we have decided to expand our online profile rather than cut back and play scared. That means strategies that will attract readers to our website on a daily basis—like a TV blog that will talk about last night's shows with brains and humour and no bullshit. We're calling it an electronic water cooler. Your name kept coming up."

"I'm flattered," Noah said with a playful false humility. He knew that false humility and its nonchalance, more than arrogance, placed him above the pedestrian reality of the situation, which was, plain and simple, a less than appealing job offer to someone who was unemployed and broke. Real humility, on the other hand, was of no interest to Noah because

it lacked imagination. He had never forgotten that as Mohammed Ali's physical powers diminished, it was his imagination that won the fights.

"I think it could be a lot of fun," she said with her throaty secret-smoker's rasp. "The starting money isn't great but who knows—you could become a Web star and we would work out a deal where you make more as the hits go up, where you are actually sharing in the profits."

Noah looked down into his wine glass, giving the impression that he was thinking about the offer when in fact he was thinking how he wouldn't want to wake up beside this woman every morning. This was the first time he had actually felt sorry for McEwen, until it occurred to him that like minds attract. Then he couldn't imagine how either of them could wake up in that bed.

"Any thoughts?"

"Well it's very . . . I mean . . . I'd never imagined myself a TV critic. You and Patrick are too good to me."

Why the fuck did I say *that*? he thought. These were the last two people on earth he would want to be indebted to, and now he was digging himself a real hole. He was still waiting for Patrick to let him know if there was any interest in his novel at the publishing house and now here was a possibility that Janice Hogan might be

his boss. He knew himself well enough to know that none of this would end well.

"It's not a TV critic as much as an outspoken opinion. If you can write one thing about a show that the critics miss, like 'How could they put her in that dress with those tits?'—something like that—and a reader says to herself, 'I was thinking exactly the same thing,' that's the connection we want to make out there. It's not criticism or editorializing, it's no-bullshit point-of-view journalism. It's intuitive and thoughtful at the same time. What do you think?"

"It sounds interesting."

"Well?"

"You want an answer now?"

"If you have one."

Noah knew he was at his literary best when on the attack, and a blog like this could be interesting. It could give him a profile. "Let's see what happens," he said.

———◆———

Noah worked with the magazine's art department to design his blog page. He suggested a short animated intro that would show him building an "Acme" bomb,

placing it under a TV set, and then quoting his favourite TV character of all time: "Wile E. Coyote, genius!" The bomb explodes, blowing the cartoon Noah to smithereens. The art department wanted something more affordable—a drawing of him smashing a TV set with an axe. They settled on the latter.

After two blogs, Noah received an email from Janice suggesting a meeting at her office. "Subject: blog. XOXO Janice."

"We've all read the first two blogs and everyone agrees that they're incredibly funny and well written, but they're finding it a little toxic. It's all funny, very funny, but if the reader senses your anger—and let's not fool ourselves, there's a very dark streak in Noah Douglas—they write you off as a crank. You're certainly not a fucking crank. We all want it to be tough-minded but we're still journalists and we need that balance. *Fairness* is not a dirty word. No one wants you to pull any punches—that's not why we hired you—but it's a hair too edgy for the brand. This is a work in progress. No one expects Frank Rich or Christopher Hitchens after day two. We just want this thing to be a home run."

Noah went to the pub across the street from her office and had two pints and a double vodka. When

he got home he had another vodka and sat down to send McEwen an email. He knew it was a mistake to go on the attack while drinking but convinced himself that the booze would, at worst, edit his potential for obsequious bullshit.

"Your wife just censored my blog. Maybe this little adventure was a mistake for both of us. Also, it's been six weeks since I gave you the outline for my novel. Have you heard anything? Noah."

He sat back and stared at his note. He liked its directness and his restraint. He wanted to call McEwen's wife "a cunt," because that's what she was, but he wouldn't play their game. He hit Send.

Within a minute McEwen answered. "My wife doesn't censor her writers; she edits them and she does it very well. I read your blog and agree with her one hundred per cent. On the novel, I didn't get a chance to read your outline myself—I've been swamped with work this month—but from what I hear around the office, there doesn't seem to be an appetite for science fiction right now. Good luck with it. Patrick."

This quick, hard left jab and solid right hook to the head momentarily stunned Noah. He sucked in another vodka, which, on its way down, surely passed, on its way

up, the gush of bile that contained his response. "What did you two do, crawl into your sexless bed and discuss how you could fuck me rather than each other? I guess every cunt needs a prick. Noah."

He backed away from his laptop without hitting Send. Some free-floating scrap of reason must have jammed the roaring turbine of vengeance that drove much of Noah's thinking. He hit Delete, picked up his drink and dropped down into the mothering hold of his beat-up couch. He turned on CNN and watched bodies being dragged out of an earthquake's rubble somewhere in northern China. He drank more vodka. He checked the lower right-hand corner of the screen for the Dow. Down 312. That's good, he thought. Let the fuckers lose it all. Let 'em die broke. He drank some more and waited for the body count out of China—fifty-six. "Only fifty-six! Hey, Wolf, you sure are scraping the bottom of the disaster barrel tonight!" he yelled at the TV. But the Silver Fox had that trademark apoplectic fire in his eyes—"This is big! This is death on a massive scale!"

"Calm down, Wolfie. You and I both know there are a billion and a half of 'em still left."

Noah finished his drink and returned to his laptop. The alcohol had pushed him right through rage and

beyond to a state of maudlin neediness. He started to type. "Patrick. I appreciate your distributing the book idea internally. Those are the breaks. I still believe in the story and would take any suggestions from you if you do get time to read the outline. Re. my crazy assault on Janice. That's so like me. She's the authority figure. I'm the bad boy. I've been doing it all my life. Can't control myself sometimes. Reflecting, I think her notes were right on. It's my nature to get defensive and go on the attack. But we're all adults and everything will work out. Tell her I think she's smart and tough-minded. Noah."

He hit Send and went to sleep on the couch, curled up with his hands clasped between his knees.

As he slept, McEwen's response popped up silently in Noah's inbox. "Reply received." This imperious dismissal would not be forgiven.

———————

After only two weeks, Noah's daily TV blog was out of control. Email and counter-email between him and Janice flew like crossfire in an Afghan village. One day his blog raged against "the fascism of cultural mediocrity" that all TV represented. The next day he

apologized to readers for his "flourishes of excess," confessing that "some TV was clearly brilliant." The following day he wrote that his confession of the day before was "provoked by the desperation of a sentient mind gasping for air in an atmosphere so intellectually rarified that mass suicide seemed like the population's only escape." Janice Hogan's offer to give him free rein to write about TV had now become more like an existential challenge. Was he a journalist or an attack dog? Did he even watch the shows he wrote about? Who was his audience? What was his voice? Was he someone who had failed in the business and now engaged in self-indulgent payback? So many questions about such an inconsequential gig about such an overworked and irrelevant subject. Noah sensed that even Janice Hogan had lost her energy for the fight by the nature of her final email: "Noah. It's over. It was not nice working with you. Fuck off and die. Janice." He could imagine her hitting Send as if she was sending toxic waste into outer space.

5

Sex

Noah had sex one more time with Jeanne at his aunt's house. When she suggested they see each other on one of her days off, he said he would have to check his book when he got home. He left and never returned. A month passed and his guilt began to wear him down. Guilt for not seeing his aunt. Guilt for not seeing his aunt because he was afraid of being drawn into a social situation with a black, working-class woman and her world. Guilt for his racism. He tried to mitigate some responsibility for the latter by defining it as a hereditary disease. Guilt for walking away from this decent woman without so much as an explanation. Even a well-told lie, one with a little heart behind it, would have shown some character, he thought. He felt ashamed because he

suspected Jeanne knew his thinking. He hated how he allowed himself to be exposed like this. And he resented her very existence for the stupid and unnecessary torment it caused him. He wanted to be free from all of it.

———⊷———

Noah stepped out of the office-tower elevator and made his way through the lunch-hour business crowd and to the street, where he felt out of place amid the downtown activity. Not only was he feeling the humiliation of pitching an idea titled "Down but Not Out on $100 a Day in Paris and London" to an airline travel magazine, but also it was rejected. He pitched to Sandy, a twenty-three-year-old features editor, who, the whole time, he thought of as "the cute little piece of ass across from me." Sandy had never heard of *Down and Out in Paris and London,* nor had she heard of George Orwell. She had, however, for some reason, made it known that she had heard of Orson Welles. Her ignorance made him horny, but on balance he concluded it wasn't worth the effort.

On the street, Noah looked at men in suits and women in skirts and blouses and heels and wondered why this was all so far out of his reach. None of them

seemed to be crazy. They all, in fact, seemed to walk with
a sense of purpose. What was their secret? He was try-
ing to figure it out when one of the women in a skirt
and a blouse and heels with a short blonde pageboy and
rectangular horn-rimmed glasses stopped him. "Noah?"

He looked at her, cocking his head to one side,
realizing he must resemble a dog faced with an intel-
lectual problem. Noah could remember many times
walking home from private school along the other side
of the street from his house and seeing his dog lying
on the front porch waiting for him, its chin hanging over
the first step. As he got closer, his dog would stand up
and start wriggling and wagging its tail, and Noah, with
normal teenage sadistic pleasure, wouldn't cross but
would keep walking like a complete stranger right on
by on the other side of the street without even a glance
at his house. His dog would stop wriggling and wagging
and tilt its head to one side, completely confused, and
look at him in the same way that Noah was now looking
at this woman.

"Andrea Scott. Not Scott anymore, Andrea Wharton
now. From St. Andrew's Church."

"Andrea Scott, from the St. A's choir?"

"Oh, God, the choir. That's me."

Noah had his own memory of St. Andrew's choir and the hypocritical moralistic crap that Reverend Newsome preached on Sundays when Noah was a kid. He remembered how the Reverend's tiny feline eyes cut into his fat, round, clean-shaven head and made him look like the Cheshire cat on chemo as he coughed up his weekly hairballs of wisdom. He was probably blowing me when I was thirteen, Noah thought. A memory he suspected was compressed into a tight little packet and jammed deep into one of those weird areas of the brain far from the conscious lobes. A memory which, he imagined, over the years could have leached its toxins into his id.

"I remember the last time I saw you," Andrea said. "We were fifteen and it was at a church dance. You went off to some boarding school after that."

"That's what they called it. It was actually a maximum security prison for children of the well-to-do who were no longer that well-to-do."

Andrea laughed and they agreed to meet for a drink the following week.

Noah had always wanted to get his hands on those two little breasts that sat up under fifteen-year-old Andrea Scott's sweater like two halves of an orange.

She was now married and had three girls in school.
With her law degree she could work half days doing
family cases at her uncle's firm. Why she ended up hav-
ing sex with Noah was a mystery to him. He guessed she
had her reasons and he wasn't going to pry. He could,
however, tell that this was her first illicit sex and that it
had definitely settled some personal score. She claimed
this was also her first orgasm in fifteen years as she sank
back into his bed afterward like someone who had just
set a record swimming the English Channel. All in all, it
was a good fuck for both of them.

Andrea had put on weight since the church choir and
was embarrassed by her stretch marks after three children.
None of it bothered Noah and she appreciated that. For
him, this was the realization of a twenty-five-year dream
to get his hands on those orange halves and that made
her very sexy, even now. However, he wasn't certain that
the same erotic impulse would survive another encoun-
ter, and when she called a few days later and he saw her
name on his caller ID, he didn't pick up the phone. She
didn't call again, and he was able to convince himself that
once was most likely enough for both of them.

Sitting at his desk with a three-shot Americano
from Starbucks, he thought about his run-in with

Andrea Scott. He scribbled a note and taped it to his
wall of "ideas" in front of his laptop:

> *Orangie porangie*
> *Puddin' and pie*
> *Had three girls and made them cry*
> *Orangie porangie*
> *With springy nips*
> *Got stretched out on fish and chips*

6

Motherfucker

During the first week in April, his aunt stopped eating, bringing her eldest son, Noah's cousin James, across the pond from his banking job in London to, as James put it, "get out in front of the curve re: Mom's funeral." It wasn't like James to move into the house and stay by his mother's side until the end. This was both unnecessary, since he was the executor of the will and already knew exactly what he was getting, and "not terribly social," since he had a number of old friends to catch up with. So he camped out at the family "farm" in the wooded hills an hour northeast of the city and threw a number of parties.

The farm was a large stone house, built in the late 1800s, which had been recently renovated by a Japanese

architect friend of James's with offices in London and New York. It had every green feature on the market, from toilets to energy supply, and was tucked into fifteen hundred acres of untouched woodlands. When trying to figure out a best-case number for the size of the family fortune, and what a first cousin's piece of the inheritance might be, Noah would factor in the price of this land as if it were rezoned for residential development. The number was astronomical.

But Noah knew that the rich didn't get rich by giving it away. These were "his people" and deep in his heart he anticipated the worst. Fuck them all was his presumptive state of mind.

———•———

Three days after James arrived, his mother died. Noah was hopeful that he could pay his final respects with some kind of grace that would put to rest the whole incident around Jeanne and the cancelled visits. He called James and volunteered as a pallbearer.

The church was less than half full and the speeches were short. His aunt had been old and not well liked and this moved things along quickly. Not surprisingly,

she had retained her worst qualities as she aged, which had dampened the enthusiasm of most who knew her, outside of the extended family.

His dead aunt wasn't heavy—in fact, at the end she was a mere wisp of anger and ingratitude—but the coffin was another story as Noah hoisted his corner onto his shoulder. Since his aunt had done some volunteer nursing service overseas during the Korean War, it was decided to shoulder the coffin military style. It was one of those Cadillac models with solid brass handles and details and was made, he suspected, out of oak. Even though the funeral director had given a quick lesson on how to hoist and hold it, the base of Noah's corner dug into his shoulder. He wasn't about to shift his grip now that they were on their way. As the coffin moved out of the church down the centre aisle, Noah spotted Jeanne. She had a seat on the aisle in a back pew. She wore dark glasses and a tight black dress made of a shiny material that buttoned up the front, with a wide black belt that sucked in her waist and pushed out her tits like two proud cannonballs. This was almost the exact black version of her nurse's white uniform. Noah smiled at her but couldn't make out a reaction behind her large sunglasses. The whole setting, the church, the organ

playing "Amazing Grace," Jeanne in black, the coffin on his shoulder, the inevitability and finality of death, all gave Noah confidence that he had put his aunt and the confusion with Jeanne to rest and that Jeanne accepted it and him. As he passed her, the edge of the coffin now digging into the base of his neck causing what he felt was the sweet pain of redemption, he thought he heard her whisper "motherfucker." He wasn't sure it was "motherfucker," especially in a church, especially during a funeral and to a pallbearer, coffin in hand. But it sure as Christ sounded like "motherfucker," and he prayed she wouldn't go to the event back at the house. Just in case, he complained of nausea at the cemetery and excused himself from the gathering afterward.

7

A Day in the Woods

On the Sunday after the funeral, James invited Noah to a party at the farm. Why should he go, he thought? To seethe with jealousy holding a glass of expensive wine and watch them ride and enjoy their fucking lives with that nonchalant pride of having everything?

He arrived by taxi, since he didn't drive. One way, it cost him $135. As the taxi pulled up to the front door of the farmhouse it passed two horses in a fenced-off area attached to the barn. "Horses," the Sikh driver said after not saying a word the entire trip up. By this, Noah figured the driver meant that his host had horses and therefore his host had money, therefore Noah had money, therefore the tip would be substantial. Noah got out, fumbled with a pocket full of fives, tens and

twenties, handed over a messy ball of bills and quickly turned to the front door before the driver could count it and calculate the size of the tip. A sign on the door said "Come in."

In the hall he noticed two well-worn but obviously expensive pairs of men's knee-high riding boots. They had mud on the soles and sat flopped over at the ankle on top of each other like aristocratic lads pooped after a sweaty cluster-fuck. James was gay and lived with a partner he had left behind in London. Noah guessed that the second pair of boots belonged to one of James's young "colonial" friends.

Noah stood with a drink, smiling at no one in particular, next to a fireplace made from plates of intersecting grey steel that took up much of the wall at one end of the cavernous addition built onto the farmhouse by the Japanese architect. He had just popped two of his dead aunt's Percocets and was on his third vodka. The space, with its twenty-foot ceiling and massive Douglas fir beams, was built to house a collection of huge, abstract paintings, priced by James in the millions. This was the largest display of consistently hideous art Noah had ever seen in one place. The space and the money made him sick with envy at the same time that the overwhelming

tastelessness of the art made him gloat with superior ty. The two contradictory emotions mixed with pills and vodka put him in a mood that could best be described as a snarling giddiness. It was here and in this frame of mind that Noah was coincidentally introduced to Mary Hobson. There she was, the gorgeous and brilliant student from McEwen's creative writing course, who, after McEwen's description, had taken up residence in Noah's sexual imagination as "The Hobson Girl." If McEwen had been right about nothing else, this was a girl you could leave your wife for, if not shoot her for.

"We have a friend in common," Noah said with a slightly ironic grin as if he held a piece of classified information.

"Oh," she replied without a hint of curiosity or coyness. This wasn't a "Lolita" response, Noah thought. This was a fawn still too innocent to recognize danger in man. He was too drunk to form anything but this one-dimensional and inaccurate impression. Her truth was, however, more complicated and perhaps beyond him. For starters, she was twenty and hadn't yet developed that second self (which comes with maturity) with its jaundiced eye locked on the first. Noah, on the other hand, lived in the world of dualities. He knew no other.

"Patrick says you're the smartest student he's ever had in his creative writing course."

"Not quite, omigod," she smiled. "Professor McEwen's pretty crazy. I mean in a good way. Do you know him?"

Know him? I hate his cock-sucking, ass-kissing, pretentious guts, Noah said, but somehow it came out, "We're best friends. Patrick *is* great. Very smart. What do you think of the art?" He waved his drink hand in a circle, a slightly drunken move he hoped she didn't notice.

She looked up and around the space, feet planted, her torso twisted. This move stretched her skimpy indie-band T-shirt across her small breasts. "Some of it's okay I guess. I'm not an expert. I mean, there may be something here I can't see."

" . . . something here I can't see." What a smart response, Noah thought. Had she subtly pulled ahead of him? His paranoid competitiveness kicked in. He had to make a move. He noticed a single log of firewood standing on end alone in front of the fireplace and picked it up. "Do you think this is here because it's been up Robert Mapplethorpe's ass?"

She blurted out a short, sharp laugh. My fucking God, she got it, he thought.

"I have to catch up with my friends. I think we're leaving."

Fucking fuck, maybe she didn't get it. She's trying to get away. I blew it. If she didn't know Mapplethorpe's work, she probably thought it was just a horrible fag joke. He could feel his panic rising. That's when the timing goes. He was familiar with the sensation.

"It was nice meeting you," she said as she backed off.

"How about a coffee in town during the week?" Noah asked. Bad timing.

"I have a lot of work, like, three exams coming up."

She was gone.

After a few more drinks, Noah grabbed a lift into town with a Jewish film director and his Norwegian girl-friend. Noah sat in the back seat alone, and after some small talk about Norway, melting ice sheets and climate change, he fell silent. The BMW 7 series sailed down the country roads absorbing bumps and dips as if it were in a TV commercial. Noah dropped his head back on the leather seat. What a fool I was to ask her for coffee after the Mapplethorpe joke, he thought. What an

idiot. But fuck her. It was a great ad lib that summed up the art, the money and the gay world all with one blow. Still, she was walking away—you don't ask someone for coffee once they've bailed out. What if she got the Mapplethorpe joke but thought it was homophobic? She's fucking twenty years old; they're all Stalinists when it comes to political correctness. His mind felt like a gaudy merry-go-round, with its horrible music and shrieking kids. He could hear the driver and his girlfriend talking, but their conversation seemed far away, as if it was in another language. This Jewish guy *would* have a BMW and a Norwegian girlfriend, Noah thought. No fucking cliché there.

The front-seat conversation continued. Noah turned his face to the late-afternoon sun and watched it strobe through the trees. His mind was momentarily at rest, as if the merry-go-round riders had dismounted and the ride kept going in sweet silence.

The BMW was now out of the country and on the freeway heading into the city. "Do you mind if we stop for deli?" the driver asked. Noah sat up. "Were you sleeping?"

"No, no."

"Do you mind if we stop for deli to-go? It's ten minutes out of our way. Bergit has never had good deli and

there's a fantastic place in the Jewish area up here." The
driver scanned the unbroken ocean of look-alike houses
that rolled to the horizon on both sides of the highway.
"I don't know who the fuck can live up here."

Noah stood with four or five others in front of the long
glassed-in counter of food. Meats—pastrami, corned
beef, smoked meat, pickled brisket; fish—white fish,
salmon belly, lox, schmaltz herring, marinated her-
ring, herring in sour cream, matjes herring; jars of
soups; trays of salads—coleslaw, cucumber and onion,
chopped eggplant; rows of knishes, kishka, farfel,
pickles—cucumber, tomato, red pepper; chopped liver,
chopped herring, chopped other stuff that was unrecog-
nizable. Noah was mesmerized. He remembered the
brothel scene in Fellini's *Roma,* the half-clothed pros-
titutes strutting their wares and yelling and pouting
and jiggling up and down in front of the customers and
the young protagonist who didn't know what to do but
knew he wanted it all. Next to Noah was a tall guy, six
foot two, maybe fifty-five, salt-and-pepper styled hair,
gold-rimmed glasses, a blue Oxford-cloth button-down

shirt, ironed jeans belted above his waist, a gold ID bracelet and a Rolex. He wasn't slim. He scanned the food with a world-weary expression, even though his entire world most likely consisted of his office, his home and his club. He poked a toothpick into his mouth and emitted the slight heaving sigh of someone who had just eaten too much. He said to no one in particular, "It's a good idea to eat before you order this stuff or you go nuts." There were no numbers and no discernable line. Communication with the counter guys was not unlike that between brokers on the floor of a commodity exchange. The Toothpick now started to talk. "Give me a pound of medium and a pound of fat. Give me four potato knishes and two kasha. Give me a large coleslaw and a medium potato salad. Is the potato salad today's?"

"Absolutely," responded his counter guy, who was already preparing the order.

"Then make it a large potato salad. How long will it last in the fridge?"

"Two days."

"Make it a medium potato salad. Give me a large rye with kimmel, sliced, and you better give me two jars of the barley soup."

"You better give me two barley soup" was an inter-

esting threat, Noah thought. What would happen if he didn't get the soup? And Noah loved "Give me." Where his mother used to take him shopping as a boy it was "May I have" or "I think I would like."

The Toothpick had finished his order when something else caught his eye. "You better give me two sheets of lox and throw in a small cream cheese." Another threat. "Is that all I need?" he asked of no one in particular. This was picked up by a small, round, middle-aged woman with a hairdo that looked like it had come out of a hat box.

"Their kishka's very good," she said, standing with the index finger of her left hand pressed against the glass, pointing at nothing in particular and showing a wedding/engagement–ring set with a diamond the size of one of the knishes.

"Give me about that much kishka." The Toothpick held his hands about a foot apart.

Now it was The Diamond's turn. "I don't see pickled tongue. Have you got tongue today?"

"Is the pope Polish?" her counter guy responded.

"Give me three-quarters of a pound. It's for my husband," as if it was necessary for all present to know that *she* didn't eat tongue.

Even though the current pope was not Polish but German, and the exchange was illogical, Noah loved its efficiency—they had tongue. Had logic applied, "Is the pope Polish?" would have meant, "We have no tongue," which they had, and this would have made no sense.

Noah could only think, Why wasn't I born a Jew? These are my people.

It was now his turn, and he could feel beads of sweat start to form under his arms and dribble down his sides. "The smoked meat, what's the difference between the medium and the fat?"

"The medium's medium and the fat's fat," answered the counter guy without any sarcasm or malice. The Toothpick had heard this and came to the rescue.

"The fat's delicious but it'll kill you."

On Noah's other side stood an extremely attract-ive blonde of about forty-two in tight designer jeans, a short leather jacket with a western fringe, and about $50,000 in jewellery. She smiled at him. "He's right. It's delicious but terrible for you."

Noah smiled back and wondered how far he'd have to travel across the universe to end up in bed with her. She looked like the Jewish version of the horsewomen he had grown up with, but with a difference. The horse

set would rather have a horse between their legs than a man. He imagined that this one fucked like a banshee but you'd need a good orthodontist practice to get in the door.

"What's it gonna be?" asked his counter guy.

No one had actually answered the fat-medium question and Noah was on his own.

"Give me a pound of the fat." He expected to hear cheers as if Evel Knievel had just landed a death-defying jump. But the fat was logical. It was delicious. No comment was necessary. "And I'd like a jar of soup."

"Pea or barley?"

"Barley."

"You want a bread?"

"Yes. The rye."

"Is this just for you?"

"Yes."

"I'll give you half a rye."

"Done."

Noah was getting the rhythm. "Give me one potato knish and one kasha and give me that jar of pickled tomatoes and a medium potato salad." Noah was on a roll and could feel it. Measuring with his hands, "Give me that much kish . . ." Trouble. "Kish what, kish what?"

he muttered to himself. The sweat was now rolling down his sides in small streams. He realized he had gotten too cute by half. But the counter guy was on to him from the start.

"A nice piece of kishka and I'll throw in a little gravy with that. You heat it up and you stick it in."

"Thank you."

"You got it."

"I got it," Noah thought. "These are my people and I got it."

But these weren't his people and as they drove home and got farther away from the deli, his connection to them also stretched out. In the back seat he thought about why he had admired The Toothpick. It was because The Toothpick was head-to-toe, take him or leave him, The Toothpick. He could be nothing else but The Toothpick wherever he went or whomever he talked to. "It's a good idea to eat before you order this stuff or you go nuts." The Toothpick would have said this to the Queen of England as readily as he said it to the customers at the counter. And this is what

Noah admired. He hated himself for being a different person to different people, constantly inventing and reinventing himself depending on the circumstances.

———•———

Once home and in the safety of the dead zone, Noah ate almost everything then listened to his messages. One was from a woman with a husky voice who worked at the same publishing house as McEwen. She had read Noah's novel outline and "found parts of it very interesting." She wondered if he had time "in his schedule" for a drink.

———•———

After two glasses of wine at a bar in a high-end hotel, it came out that she wasn't at the editorial level but at the secretarial level. She was tall, about thirty-three with a strong jaw and large hands and feet and a pretty good body. He could tell she smoked. When she went to the ladies' room between drinks, Noah watched her cross the floor with long, aggressive strides and thought she was to femininity what Albert Speer was

to architecture, and this held interesting possibilities. However, there is always a distance to go before the final destination in bed, and she had strong opinions on issues on which Noah felt one should not expend too much energy.

"I hate the red carpet on Oscar night!" she said with genuine disdain. She didn't hate the Oscars as a whole. This would have been fine with Noah, given its cultural implications. But she hated the red carpet *only* and with a vengeance. He didn't challenge this because he knew that the road to bed can be not only long but rocky. She also "hated the North American way of tipping." She preferred the French way of "service included." She was militant on "service included" and pronounced it with a Parisian accent. She also "love, love, loved" France. Noah didn't feel any need to hate or love it. He was okay with letting France be what it was without getting involved: good food, structuralism and Nazi collaborators. It wasn't that he had no opinion on these subjects, he just didn't have the energy to gang up on tipping. None of it was Hiroshima or poverty in America or AIDS in Africa or Proust or Mahler, on which he might have something to say. So he kept his distance and made no serious errors and

she accepted his invitation to go back to his place for another drink.

Noah prepared two large vodka martinis in his tiny kitchen and returned to the living room but she wasn't there. He saw her boots on the floor next to the bathroom. The door was open. He looked in—nothing. He moved carefully to the bedroom, balancing the drinks, and there she was sprawled on his bed stark naked. "Don't touch me!" she screamed loud enough to bring the police. Noah realized it was now time to return to earth.

As he moved her out and down the stairs of his building, Don't Touch Me told him that two editors at the publishing house had read his novel outline and there was a split decision on whether to go forward with a small advance. To break the tie, they had given it over to McEwen, since he had brought it in. He had passed and killed the project. She said McEwen told her the story in the copy room with his hand under her skirt and between her legs. This little kiss-and-tell seemed to give her a sadistic pick-me-up, and by the time they hit the street she was playfully grabbing at Noah's crotch. But Noah had limits that sometimes surprised even him, and he stuffed her into a taxi as if he was putting out the week's trash. He had no idea

how far away she lived but gave her a twenty for the fare without a goodbye. As he closed the car door, she shrieked at him with her throaty smoker's rattle, "I hated it too, fucker!" He stood on the curb and watched the cab drive into the night.

8

Hardball

Noah returned to his apartment, hoping that Don't Touch Me had returned to Mars. He opened his email as he worked his way through the untouched martinis. A note from the TV show that had dropped him asked if he could return two DVDs he had rented for research on their account. *Terminator 2* and *Casino* were two months late. The next was from his cousin James. "Dear Noah. We've taken care of the will and Mom mentioned in it that there was a picture in the house you liked—a photo of Salvador Dali taken by her cousin Simon Barber in Malaga in the 1940s. Evidently Simon was pretty famous in his day and Mom wanted you to have it. Distributions to family are being handled by Louise O'Hagan. Her number is below. Call and she'll arrange to have the

Dali sent to your place. Your condolences and help at the funeral were greatly appreciated. Cheers, James."

They had fucked him as expected.

He finished off the first martini and slumped back in his chair. He stared at the wall across from his laptop where all of his TV "idea" notes were taped. What a fabulous, delusional, fucking joke, he thought.

The list had been there for so long it had become transparent to him. But now that he forced himself to read his ideas, it started to make him sick. Not because the ideas were so bad, but because they represented an aimless mind lacking any intellectual standards:

"Don't Breathe: miniseries—accidental release of contagious bio-weapon spells end of world played out on fictional CNN."

"The Seduced: contemporary Macbeth—a cop investigating murder of a rich businessman falls in love with wife who committed the crime."

"Life with Cheetah: reality show—a chimp is adopted by a normal middle-class family and how they deal with it."

"Know Thyself: PBS documentary series—although your life is made up of thousands of days and incidents, they can all be reduced to one moment when you know

who you are, when you see yourself face to face. Middle America looks in mirror."

The list went on and on, a jumble of naive long shots and dated insights, none of which would be pursued. He reached over and ripped as much of it off the wall as he could with a few swipes, then dropped back into his chair and finished off the second martini. Even this act felt like a third-rate drama that would have been cut from a good script. His mind flipped through the last few months: his wrecked marriage, the McEwen betrayal and his novel rejection, his mostly regrettable sexual adventures, the loss of his TV job, the Dali photo in lieu of his "rightful" share of the inheritance. Add it fucking up, there was a conspiracy against him. Not an organized conspiracy—it was more insidious than that. None of the parties knew the intent of the other. African killer bees, he thought, don't know what's on the next bee's mind and don't know that their group effort will kill, but the biological conclusion is the target's death. This is what he was now convinced was facing him. Noah represented pointlessness in an absurd universe and this made him a threat to the false god of order. He had to be eliminated.

Noah felt assaulted by his manic self-examination and needed air. He left his apartment just after three in the morning and walked the streets. He had never done this before at this hour and wondered if this was also a bit of cheap drama. His mind was racing. Just because he recognized the crimes of others didn't mean that he was beyond guilt. McEwen's role-playing, his competitiveness, his self-serving friendships, his references to obscure books he had read and even ones he hadn't read, his need to impress, to exaggerate his achievements, to take credit—these were Noah's crimes as well and he knew it. But McEwen was at least a player.

The street was locked up, and the clutter of lit neon and plastic signs gave it an empty glow. An orange traffic light flashed off and on like the city's pulse. The odd taxi passed. Garbage men in fluorescent yellow vests loaded a garbage truck. Noah noticed two men coming in his direction. He recognized one, a local street character who had been around as long as Noah had been in the neighbourhood. He was in his thirties, grimy, with a beard that curved up the sides of his face and covered his cheekbones, encircling darting, cold eyes. He wore a ball cap on backwards as if his sense of cool was a good ten years out of date. His jacket was ripped and decorated with heavy-

metal patches. His jeans were tight and unwashed and his white high-top sneakers looked like he had taken them off someone of a different size. His partner was taller, wiry, with unhealthy long hair that hung along both sides of his abnormally narrow face and below his shoulders. Noah moved to his right as close as possible to the storefronts as they passed.

Then, "Hey, man."

Noah looked over his shoulder but kept going. They turned in his direction. "We got a friend back there who just threw up blood and we gotta get him to the hospital. Can you loan us a twenty?" The urgency of their request was out of whack with the nonchalance of their lumpen demeanour.

Noah said "Sorry," and kept walking.

"Hey, man, our friend's dying. Is twenty bucks gonna kill you? He's fucking dying." Noah kept going then felt something slam into the back of his head and neck. He sprawled forward onto the cement. The Ball Cap smashed him again with a large plastic garbage can, this time letting it go after the blow. The Long Hair was now on top of him, digging at his pockets while The Ball Cap started kicking him hard in the back. Noah could feel a deep stabbing pain with each blow

and knew that that had to be his kidneys. He curled his
arms over his head but one kick got through and felt
like it had ripped off his left ear when a horn started
blaring. The two men took off. Noah got to his feet and
felt his ear. There was blood on his fingers. He noticed
a guy in a car, stopped in the middle of the street. He
assumed this was the horn blower. The driver yelled
out a silent "You okay?" from behind upturned win-
dows. Noah waved him off. The car drove away. The
men were gone.

Back in his apartment, Noah washed off a cut and
scrape just below his ear and held a paper towel to it
since he had no Band-Aids. Band-Aids were one of the
many normal necessities he would not think to buy
when furnishing his own place. Each time he raised his
right arm above his waist he felt the stabbing echo of the
kidney blows. He poured himself three ounces of vodka
with his left hand then returned to the bathroom mirror
to admire his wound. For some reason the attack hadn't
unnerved him. This wasn't a game of one-upmanship
he was used to winning or losing; this was the "real
thing" and he was still standing. He drank his vodka,
eased himself into his couch and turned on CNN.

Noah got up late and went down for a coffee at Star-
bucks, then walked the two blocks to his magazine store
and picked up his daily *New York Times*. On his way
back he passed the laneway that led off the main street
and split the block in two. This was where restaurants
and stores left their large garbage containers for pickup.
In the lane about fifty feet from the street entrance he
spotted The Ball Cap who had mugged him the night
before. He was drinking a coffee and shifting from one
foot to the other. It was obvious to Noah that he was
waiting to sell or buy crack. He had seen other dealers
in the lane and they all behaved the same way. Noah
passed unnoticed and was sure that had he been seen,
it was unlikely The Ball Cap would recognize him or
even remember him. Noah hurried up to his apartment
and, in a move that seemed oddly normal to him, got his
old hardball bat and returned to the street. It didn't feel
unusual or provocative to carry a bat on the street since
he had done it before in his life on the way to pickup
ball games. Leaving his building's front door, he turned
in the opposite direction from the lane and circled the

block. He passed the rear of his building down another lane that ran parallel to the main street and intersected with the lane that ran off the street where The Ball Cap was stationed. He turned into the intersecting lane and saw The Ball Cap facing away from him, still moving from foot to foot with his coffee in his left hand and a cigarette in his right hand dangling down by his side. He knew he had to move without hesitation. He had seen enough "guy" movies in his life to know this basic principle of violence. He also remembered a colour commentator during a World Series game on TV—it could have been Tim McCarver—commenting on a third baseman's ground-ball error, "Play the ball—don't let the ball play you." Noah never forgot that elegant rule. He picked out a spot on The Ball Cap's right forearm and without breaking stride swung all out. Noah felt the bone snap under the power of the bat as the searing pain from last night's kidney blow took his own breath away. The Ball Cap screamed, stumbled to his left into the garbage containers, slipped onto one knee, staggered up and without turning back, his left hand gripping his dangling right arm, ran straight out of the lane into the street and disappeared. Noah hadn't expected this reaction. In fact, he hadn't thought what might happen

beyond the initial blow and now realized how stupic he
had been and how lucky he was. He turned and quickly
retraced his route back to his apartment.

He felt more shaken by his attack on The Ball Cap
than by The Ball Cap's attack on him. This capacity for
violence was something he had not known about himn-
self. It both surprised and excited him. He poured a
vodka. It was only ten-thirty in the morning, and on this
occasion it was to calm his nerves. However, Noah knew
he was drinking daily for self-medication. He drank to
quell his anger over disappointments. He drank to han-
dle the reality of his unemployment and financial sta-e.
He drank to end-run his ambivalence during sexual
advances. He drank to forget the sycophantic impulses
that dogged him in his half-hearted efforts to become a
person of reputation in a social world he despised.

9

Melting

It was the beginning of spring, and rather than a time for renewal, for Noah a bleak acquiescence had set in. Too much alcohol, no work and waning social contact.

He opened McEwen's email with a degree of anticipation. "Noah. My book launch is on campus in the reading room of the Matthew Douglas Building. Since it was named after your grandfather, both my editor and I thought it would be a great idea to have you say a few words. Hope that appeals. We're sending you a copy to read. You'll be getting an invitation by email with time, etc. By the way, in case you haven't heard, Janice and I have split up. It was pretty mutual. Best, Patrick."

Noah suspected that for two people as self-centred as McEwen and his wife, "pretty mutual" meant a

blood-splattered cockfight. These two were the type for whom an admitted mistake was an admission of failure, and failure was anathema to such "perfect" lives. When they had travelled to northern China, this tourist hell was "wonderful," as was Siberia in the summer if one could "handle the mosquitoes," which simply took "getting used to."

He was aware that McEwen was cashing in on his association with Noah by holding the launch at the Douglas Building, and he imagined the poetic justice in giving a speech that ripped McEwen another asshole for fucking him on the book proposal. This was his chance. After all, this was Noah's family turf, and McEwen should be thankful that they allowed his mediocre talents on hallowed ground.

Noah sat forward, his hands suspended over his keyboard for that moment of pre-email reflection. He started to type his reply:

"Patrick. Love to speak. Send the book. Sorry to hear about you and Janice. Hope things work out. Noah." He hit Send and poured a drink.

Noah read McEwen's book. It was impossible for him to
see it for what it was through the fog of envy. What he was
able to do was pick up on every writing weakness, from
an inappropriate word usage to a missed comma. He
was able to dismiss any example of eloquent style as self-
conscious "watch me write" typing. He was able to see
why it might appeal to a publisher looking to sell air-
port copies by the pound, and defined this as "aggressive
mediocrity." And by the end he could close the cover
and, for his own piece of mind, declare the book a total
piece of shit.

———•———

The next morning was bright and warm and the last
melting ice left puddles that reminded Noah of exam
time at university, when the girls peeled away coats and
sweaters and bared their legs and shoulders. Eighteen-
year-old spring tulips, velvet skin petals with a scent that
was out of this world for the lucky few who were able to
get their faces close enough.

Noah was sitting with his *New York Times* and coffee
in the Starbucks below his apartment when The Hob-
son Girl approached and stood in front of him until he

looked up. She was holding a coffee and her backpack of schoolbooks and didn't say anything but smiled and indicated with one hand that all the other tables were full and could she sit with him.

"Sit, sit down," Noah said with what he sensed was a bit too much enthusiasm. He pulled back. "I was just about to leave. I have a meeting. But sit. How are you?"

"Fine."

Another wonderful, monosyllabic response from the twenty-year-old fawn.

"Have you seen any hideous art lately?"

"No." She smiled. It was clear that she remembered the gist of their conversation at his cousin's farmhouse.

"Don't you have exams about now?"

"Yeah."

"Are you ready for them?"

"No."

"Only the best and the brightest aren't ready."

"I wouldn't say that's me, and I'm still screwed."

"I'm sure you're exaggerating."

"Yeah ... well ..."

"Do you have any flaws?" Noah wasn't sure why he asked this, but it seemed kind of sexy and he thought it

could be the kind of question a twenty-year-old girl may think was deep.

"Self-obsession."

"This is good," Noah perked up. "Very good, very healthy. The ethical by-product of self-obsession is self-awareness."

"I'm not so sure about that."

"Don't underestimate this flaw. A person without self-awareness is a person without her own sense of morality. This is a person who is much more likely to accept the morality of a religious or state authority. This is the fascist mentality—give up personal morality to the moral code of the state and allow the individual to ignore personal responsibility. This enables him or her to say, when the state is criminal, 'I was only taking orders.'" Noah stopped and looked her in the eye. "I'm lecturing and you thought you were on a break."

She didn't respond but did smile.

Noah wondered how these girls do it, how they remain silent without a hint of impoliteness, how they are able to be who they are without effort or need for decorum. He could only vaguely remember his own monosyllabic self, which had disappeared ages ago along with the muscle tone and flat torso that, at twenty-one,

he maintained without lifting a weight or running a lap. But now he had to be realistic and play the cards he held.

His conversational angle was, like always, tactical. With some women, drinks and a good restaurant worked. With others, like The Hobson Girl, who was intelligent, young and non-linear, it was all in the non sequitur.

"What are *your* flaws?" she asked, surprising Noah with an uncharacteristic interest in *him*.

"That's a very long list and another conversation. How is your creative writing class going?"

"Not bad."

"I thought you were the star."

"Oh, please."

There was now something more familiar in her responses. She was, he thought, playfully chiding him. This was the beginning of a certain kind of male-female conflict that laid down the differences between the sexes— a difference that is the core ingredient in sexual tension.

"What sort of stuff are you writing?"

"Short stories."

"Poetry?"

"Not me. Poetry is beyond me."

"Do you read it?"

"Some."

"Who?"

"I don't . . . different stuff."

"Name a poem you like."

"Rilke's 'The Panther.'"

"You win."

"What do I win?"

"The grand prize. That is one of the great poems.'

"I didn't write it. I just read it."

Noah was interested in her judgment. She was certainly smart, though only twenty years old. But it was her lack of maturity that attracted him. She spoke her mind with a direct innocence. She was not yet seasoned with cynicism or certainty. And he was not just interested in her judgment, he wanted to be judged by her. He was realistic enough to know that that was the most attention he could expect.

"Have you ever committed a crime?" he asked as easily as if he were asking for her favourite colour.

"No-ah!" she said with a sharp laugh. The end of her "no" went up an octave with an "ah" which was still heading up at the finish. Was this the "Are you nuts?" version of the word, or had she admonished him using his first name, "No-ah," in a strikingly intimate way?

"Just wondering," Noah said, sitting back with his right arm hooked over the back of his chair.

"Have you?"

"Yes. And it was curiously liberating."

"I don't think I want to hear any more about this."

"It wasn't as if I killed anyone," Noah said with a reassuring chuckle.

"That's good. I have to go anyway."

"Would you like to go for dinner some night?"

"I can't. Sorry."

"Is it the age difference?"

"I'm seeing someone." The Hobson Girl stood up, finished off her coffee and picked up her backpack. "It was interesting talking to you, as usual."

"The same." Noah smiled as if to say that part of him was in this encounter and part was looking down from above with a sociological curiosity.

He watched the movement of her ass, so perfect and tight in her faded jeans, as she walked out.

Noah wore his only suit to McEwen's book launch. He folded a kerchief into the breast pocket and wore a school

tie. When he dressed up, it was never contemporary or hip, it was "sensible traditional." Noah knew no other way. When he didn't dress up, he also had little sense of style, and as his financial situation turned grim he began to look more and more like a shambling street person. Coming from old money, his idea of status had nothing to do with outward appearance. They "*had* hats" as his mother used to say. "They didn't have to *buy* hats."

McEwen's editor introduced Noah as a TV writer to a crowd of about fifty academic and literary types with glasses of white wine. Noah took the TV reference as a cheap shot and thought he would answer it by pushing the envelope of decorum. After all, this was an open-minded literary crowd.

"I remember my first TV contract on a network series. It was a lot of money for hack work, more than I had ever made. For me, the deal was like the orgasm and the actual writing was like trying to get the woman out of my apartment after I was finished." Silence. The crowd either didn't get it or got it but chose to stand above the crudeness of reducing writing to a quick fuck. Noah had to dig himself out. "I keep forgetting this isn't about me." This got a smattering of chuckles, but the sweat started dribbling from his underarms down his sides

under his Oxford-cloth button-down shirt. He pulled out the heavy platitudinous guns: "Let me talk about Patrick and this remarkable book."

He gave both McEwen and the book an eloquent blowjob, and when he was finished, his earlier foreplay with the truth was forgotten. The applause was loud and appreciative. Noah stepped down to a firm handshake from McEwen and went directly to the bar in search of a stiff drink. He had been a bad dog but after a slap on the nose had behaved himself and was given a pat on the head. Besides cheap white wine, there was one bottle of vodka and one of gin behind the bar. He asked for a quadruple vodka.

"A quadruple?" the bartender asked with some sarcasm.

"Yes, a quadruple. Do you know what that is?"

"Yes, sir, but I only have one bottle of vodka."

Noah, still wound up from the applause, leaned in and with a low hiss responded, "It's not my fault that these people are a bunch of cheap bastards. I'm an alcoholic and I want a quadruple vodka. My grandfather built this building, so please don't fuck with me."

He got his quadruple vodka, downed it in three gulps and, staring at the bartender, picked up one of the

pre-poured glasses of wine and turned to mingle with the crowd.

"Terrific speech," said a grey-haired man in his early sixties with a dowdy, smiling wife in tow.

"Thank you." Noah responded. "And you're . . . ?"

"John Garland. This is my wife, Morwyn. We're both at Trinity. What TV show are you writing now?"

"Some risky stuff. We don't know if it'll get done in this economic climate. They all want mainstream crap that will get high numbers or the advertisers will run for the hills."

"What about public broadcasting?" his sexually limp wife asked with a sterile grin. He couldn't stop thinking, Who on earth would *fuck* her?

"The public broadcasters are worse than the private-sector whores. They want numbers but there's no financial reward. They have only one real power and that is to say 'no.' I have no idea what those fuckers are thinking. They seem to be nothing more than pathetic ass-kissers and cocksuckers. They make me physically ill."

The dowdy wife's smile was frozen on her grey, lined face as if she had nowhere to put it. It just hung there behind glasses far too big for her shrunken head. She and her husband stared at Noah, mute.

Noah realized that all of his anger toward McEwen and his self-disgust for playing his shill was now spilling out in the faces of this hapless duo. They were there to applaud McEwen's success and they were an easy target.

"But I'm a suicidal alcoholic, so you really shouldn't listen to my opinion," Noah assured them. "Are you guys birdwatchers?"

"No."

"Neither am I. Can you excuse me?"

Noah spotted The Hobson Girl and pushed his way through the bodies to get to her.

"It's The Hobson Girl."

"Hi. I thought your speech was very good."

"A blowjob is easier and more sociable than genuine critical analysis that requires some thought and may be impolite." Noah gulped back his wine and momentarily lost his balance. "Oops. Sorry. I think you're very beautiful."

"I think you're a little drunk, right."

"A little. I have a problem with open bars." Noah now realized he was suffering from "Hobson's disease"—the uncontrollable urge to sleep with this perfect young woman and teach her more about sex than she could even imagine. Just then McEwen approached.

"I guess you two know each other."

"Yes," Noah said, able to stop there and hold back a witty reply. He realized now how effective the single-word response could be and how seldom he used it.

McEwen turned to The Hobson Girl and said quietly, "Give us a minute." She smiled and walked off. It was now clear to Noah that they had an intimate shorthand. This was a bad sign. McEwen took Noah's arm and walked him a few feet in the other direction. "She's not who I left Janice for. I think you should look elsewhere. I mean, Christ, girls that age can walk out on you because they meet a guy with a cooler car. She comes on more sophisti-cated than her years, but the fact is she's twenty years old."

This all sounded like a classic non-denial denial, and Noah was sure that McEwen was screwing The Hobson Girl and that was that.

"Your speech was terrific," McEwen said, gripping Noah's forearm.

"Well, the book was great."

"You think so?"

"Terrific, amazing."

"I'm sorry they passed on your outline, but the pub-lishing business has become more about business these days than publishing."

"I guess so."

"We'll play squash next week."

"Whenever," Noah replied flatly. McEwen was too high on wine and his conquest to notice the lack of affect in Noah's answer. He gave Noah a hug and was gone.

Noah picked up another glass of wine and wandered through the heavy glass and wood doors of the fifties modern building that opened onto an inner courtyard where a running pool dribbled under large slabs of shale. A few people were standing in the mild night air smoking cigarettes. Noah heard what sounded like an angry commotion and noticed that someone who looked like a student was arguing in a slightly threatening way with a man and his wife. Noah moved closer. He could see that the student wasn't a danger. It was clear that he was attacking the author's reputation rather than the couple, but he was drunk and seemed slightly unpredictable.

"He's a fucking fraud!" the student spat, jabbing a finger at the couple.

"Maybe you should leave," the man said.

"Fuck off. I have as much right to be here as you do. I go to this fucking college and I take a fucking course from the great writer being honoured here tonight and

he is not just a fraud but a fucking liar who's jealous of my work. This prick is competitive with his best students, mainly male students, not the pretty litt e girls, because we make him look like the fucking med - ocre hack he really is. So fuck you! And fuck him and his fucking event!"

At this point the student moved closer to the couple. Noah, feeling quite drunk, stepped in.

"I think you better leave." Noah tried to say this without slurring his words.

"Fuck you," the student replied with a contemptu- ous drawn-out "youuu."

"I said, you should leave," Noah repeated more aggressively, slurring "should."

"And I said, fuck you," the student replied, poking a finger into Noah's chest.

The finger triggered an explosive and inappropri- ate rage in Noah that had nothing to do with the cir- cumstances. It came from somewhere else, somewhere deep inside. It was the need to hit, to punish. Noah dropped his glass of wine and with both hands pushed the student as hard as he could, sending him backwards, tripping and falling into the shallow water and landing against one of the slate slabs.

"Get the fuck out of here, asshole!" Noah shrieked with perfect articulation, making the onlookers take a step back. The student crawled out of the water and left through the garden gate. There were murmurs to the effect that "someone had to do something," but it was clear that Noah had gone too far. After all, these were literary people, who worked out their differences with words, not with fists. There had been too much rage in Noah and no one wanted to get too close. The smokers went back inside. Noah stood in the dark, his head spinning. Had he defended that scumbag McEwen? Or was this about something else he didn't understand? He felt sick and decided to walk home to get some air.

10

Shit Happens

The next Wednesday, McEwen called to set up a squash game at the university for eight o'clock that night. He had already booked a court. Noah was pissed off at McEwen's assumption that he could set a game without any notice and wanted to pass, but he didn't. They arranged to meet at McEwen's university office at seven-thirty and walk to the gym from there.

Noah arrived at the building with his racket, shorts, sneakers and T-shirt rolled into a bundle. The main door was open until eight and he took the elevator to the fourth floor. This was a staff office building and no one was around at this hour. He found his way to McEwen's small office and knocked. McEwen opened the door holding a portable phone. He was on a call.

"Come. Sit," McEwen whispered, covering the mouthpiece. He indicated one of two guest chairs in the cramped, book-filled space, then sat and swivelled away from Noah to face his desk, which was pushed up against the wall beneath a large double-pane window with the blind down for nighttime privacy. You wouldn't want to interview female students at night with the lights on and blind up, Noah thought. That would be like fucking in a fishbowl. The door swung closed by itself. Noah imagined McEwen's first one-on-one with The Hobson Girl in this space. She would have been sitting where Noah now sat and McEwen would have swung around and away from his computer on the desk, crossed a leg, leaned back and talked to her with his patronizing grin. You didn't score with these girls by being honest or self-deprecating, as Noah had been. You score, he thought now, by being controlling and self-assured. They all wanted to fuck a father figure.

McEwen wasn't trying to maintain any privacy with his call. In fact, Noah could tell that he wanted Noah to hear every word. McEwen was one of those people who talked to everyone within earshot when he was on his cellphone, especially when the conversation was about his own business or literary endeavours. Strangers wait-

ing for a bus or in line at Safeway all had to know that
McEwen was a player.

"That's good, that's very good. It's all very good
news. And you've done a terrific job. You have. The *New
York Times* is better than a poke in the eye. I'm late for
a squash game and I will read it online as soon as I'm
finished. Take care."

McEwen quickly stood up and ran both hands
through his hair. His cool telephone demeanour evap-
orated. Noah started to stand but McEwen held up a
hand to stop him.

"No. No. Sit. Sit." He was frantic. Noah had never
seen this side of him. "I have to cancel! I can't play! But
I want you to wait. You have to wait. That was my book
agent in New York. The fucking *New York Times* reviewed
my book for next Sunday's book-review section and they
loved it. She just emailed it to me. They fucking love
me. And she's talking to the U.S. publisher about a big
advance for the next book. When it fucking rains it pours,
Noah. When it fucking rains it fucking pours."

McEwen dropped back into his chair and swung
around to his computer. Noah sat staring at McEwen's
back and didn't say a word. He sensed that McEwen
wouldn't hear him anyway. After all, he had lied to his

agent that he was going to play squash and would read the review later, and it didn't appear to bother him for a second that Noah had heard the lie. It felt strange to Noah to remain silent, not even a perfunctory "sounds good" or "congratulations." He just sat there not knowing what to do or say. He found himself looking at McEwen from a distance as if he were watching some kind of wriggling bug in a jar. He could tell McEwen didn't care whether he was there or not. In fact, it was clear that Noah had just moved from the endangered list in McEwen's world to extinct species. He was now invisible.

McEwen ran his hands over his computer keyboard, calling up his email in search of the review while Noah glanced around the room at the signs of a methodically invented life. He had been in the office once before but all he had taken in was "professor's office." Now things were coming into a finer focus. The bookshelves not just full but stuffed in an unruly way as if to denote a mind that was everywhere at once. The massive anthologies; the well-worn volumes of poetry; the classics shuffled randomly amongst the contemporary thinkers, every important name visible; the framed photos from trips to Africa, South America, London, Moscow, Tiananmen Square, jammed with a studied clutter into the small

areas of available wall space; some remaining Christmas cards; his squash and tennis rackets; a bottle of Dom Pérignon, a gift from someone who could obviously afford it; and the clichéd trinkets from his travels, which included pieces of Inuit and African art as well as a machete with a decorative handle that dangled from a leather strap.

"You have to hear this, you have to hear this," McEwen chirped like an excitable parakeet. He had the review up. "This is the first line—'Few comic novelists dive into the cold, dark waters of truth with the abandon of Patrick McEwen in *A Horrible Night.*'"

Noah sat there looking at McEwen's back, listening to his distant voice read what Noah's mother used to call "supercilious drivel." It wasn't until later in life that he had understood how she used the expression to refer with contempt to a conversation that bored her or was over her head or that she found self-serving. But when he was too young to know what "supercilious" meant, Noah still liked all of its *s*'s and syllables. It also sounded adult and sophisticated, and he imagined it had something to do with the brain or brainy people and he had a picture of their ideas as they slid from their brains, through their nasal passages, where they

collected mucus and continued down into the back of their throats, where this mixture combined with their words and formed a thick dribble called "drivel." And at this moment, things all made sense to Noah. His life had recently felt to him like it was adrift across some featureless white plain lacking any points of reference. He had once driven across the Bonneville Salt Flats in Utah, where there was no road, nothing growing, just a flat white surface for miles on end in all directions. But he was now staring at a secret door that had miraculously appeared on that plain, a door beyond which lay something completely different and completely unknown and all he had to do was step through and he would change his life forever. He was sure no one had seen him enter the building and take the elevator up to McEwen's office. It all seemed so easy. He simply had to open the door and step through. It was logistics, not the right or the wrong. He felt as if the decision had been made for him by someone else, someone he couldn't see, a being or thing who was in the room with him. Noah took the T-shirt from his bundle of squash stuff and wrapped it around his right hand. McEwen kept reading aloud. Noah reached for the machete. It didn't have the heft of his baseball bat and wouldn't have the

momentum, but he calculated that the blade would make up the difference. He knew where the jugular ran down the front right side of the neck from a biology class at university. He was surprised by his state of mind, a state quite foreign to him. He was capable of doing what was about to come. This wasn't him, he thought. This was how cold-blooded killers think, how psychos think. Or was it how the highly trained Navy SEAL marksmen in the U.S. forces think when they are about to take down a target that is threatening the free world and its way of life? He had reached a point of style and had left morality far behind. He was exhilarated by his cool, by his lack of fear. He raised the machete to the level of his hip as McEwen continued to read aloud from his computer. Noah had focused on a point between the jaw and the base of the neck when McEwen raised his left hand and hooked it over his left shoulder to scratch the left side of his neck. Noah lowered the machete and waited for him to stop scratching, as if it was wrong to interrupt this attempt to satisfy an itch. McEwen finished scratching and continued reading, and Noah stood up and with an all-arm tennis swing, not a squash swing from the wrist, brought the machete down hard across McEwen's neck

with enough force to cut at least four inches into him. McEwen plunged forward and to his left, grabbing his neck with his right hand. The only sound he made was a muffled gag. The jugular had been cut and blood pumped out of him like a ruptured water main. Noah didn't expect that much blood that quickly and almost vomited. He wanted to run and have someone else finish what he had started but he knew he had to keep going. The damage was done and to stop now would be insane. He swung again and again in the area of the first cut, slashing at McEwen's neck until his body collapsed forward onto his desk, blood gushing onto his computer in horrible rhythmic spurts, each one draining more life from him until the gushing and spurting slowed and his body lost all resilience and lay flaccid on the desktop. Noah found it hard to breathe and gulped for air. He was, at this point, not a human being but an animal struggling to survive. He pulled the T-shirt from the machete and dropped the weapon on the floor. He rolled the T-shirt into the rest of his squash stuff and took off his jacket, which was blood splattered, turned it inside out and folded the squash stuff into it. With his sleeve over his hand, he opened the office door and walked to the fire exit again, using

his sleeve over his hand to open the door onto the grey-painted cement stairwell. He hurried down the four flights, checking his clothes and wiping at his face for signs of blood. He exited through a one-way door, kicking the bar with his foot. It opened into the dark at the building's rear next to an empty parking lot. No one had seen him and he was satisfied there was no blood splattered on his face or clothing. He walked quickly toward the gym and dialled McEwen's office on his cellphone. He left a message on the machine when it picked up. "I'm at the gym and it's eight o'clock. Just wanted to know if you're on your way." He hung up and walked as quickly as he could.

He arrived at the gym in less than five minutes. He went down to the towel counter in the area outside the weight room and squash courts and asked the student attendant if a "Patrick McEwen" had arrived for his court. She checked her court schedule and said, "Not yet." Noah said he was supposed to meet him for an eight o'clock court and could he take the court and wait for him inside. She looked at her watch, saw it was an hour from closing, smiled and let him in without a guest pass. He took a towel and thanked her for trusting him.

Noah sat on the floor of the empty court, his legs outstretched, his back against a side wall which was streaked with ball and racket marks. He was in a place where nothing bad happened, a place of sportsmanship and camaraderie, and for the moment, he felt safe. His breathing slowed, but his feet and hands were still shaking—the slaughter's aftershock. He dialled McEwen's cellphone and left another message, that he was on the court and waiting and knocking the ball around by himself, and that if McEwen couldn't make it, it was no big deal—he had his cellphone with him and McEwen should call if something else had come up. Noah waited twenty minutes, changed and walked home.

———◆———

He knew he was going to need alcohol to get him through the coming days and picked up a forty-ounce bottle of Absolut at his local liquor store. The cashiers and customers all seemed strangely passive to him, as if they were moving in slow motion. He wondered if he appeared jumpy to them, hyperactive, out of sync with the normal rhythm of things, and whether this was giving something away. He tried to appear relaxed and

smiled in response to the cashier's comments, but his smiles seemed to come at the wrong time, either too soon or too late. He started to sweat and wanted to get out and into the night.

Once outside he headed for the closest side street. This would be a detour on his route home but would also be dark and unpopulated. Once off the main strip, he unscrewed the top of the Absolut bottle and gulped down at least four ounces without taking the bottle from its plastic bag. He screwed the top back on, then remembered his bloody clothing. He wrapped the bottle in his gym shorts and stuffed the bloodied T-shirt and jacket into the plastic bag and tied it tight. When he passed the first public trash bin with a door flap, he stuffed the bag in and kept going. He stopped twice more for gulps from the bottle and arrived home feeling numb.

He thought of turning on the TV news but then decided to wait for the morning. He poured himself three or four more ounces and sat on the edge of his bed with only one thought in his mind: there was no turning back. The chill he felt was, he thought, what people must feel when they are told by their doctor that they have a serious chronic disease, that they have diabetes, or a kidney disease which will require

dialysis for the rest of their lives, or that they have non-Hodgkin's lymphoma "but it's treatable." You live with it, he thought, that's what you do. Noah finished his drink, kicked off his shoes and curled up under his covers without taking off his clothes. He tried to imagine what his demeanour would be in his first conversations about the "horrific murder" and wondered whether he could express the necessary shock. He then fell asleep thinking that though his mother was dead, he was alive and that would make her feel good.

Noah didn't wake up until after eleven the next morning, when the phone rang that long-distance double ring. He didn't answer it. He lay on his back, staring straight up, and came to consciousness as if the events of the night before had been written on the ceiling then let go and crashed onto his face. The phone rang again with the long-distance ring. He picked it up. It was his cousin James from London. His "colonial mate" had just called with the news. After a few obligatory words of condolence for the loss of Noah's old friend, James soon slipped into a chipper, gossipy desire for more gory

details, which made it unnecessary for Noah to feign any shock or sorrow.

"I was supposed to meet him for squash last night. When he didn't show up I went home thinking he had forgotten until I heard the news."

"God, you were supposed to meet him last night?"

"Yes."

"Fuck. It could have fucking been you too if you had been with him."

"Maybe."

"Fucking Christ, man. I don't think I've ever known anyone even vaguely who's been murdered. A couple of suicides, but not this kind of thing. Fucking hacked to death. It sounds like fucking Rwanda. Do they know how many did it or who or why?"

"No idea. It's all like a bad dream."

"Do me a favour and give us a call if you hear any more interesting stuff. This could even be a sex thing. Was he gay?"

"No. But he had just left his wife for a younger woman."

"Fuck me. Hell has no fury like a woman scorned, mate. If I were a betting man I'd put my money on the wife. I hope I didn't wake you."

"No."

"Stay in touch. It was great seeing you at the farm. We should get together more often. You should come to London."

"I might do that."

"Take care of yourself. Cheers."

"Cheers."

They hung up. Noah thought that he played that quite well. He now saw what his near future looked like—lies, deception, performances. Say as little as possible and be consistent. Don't get tripped up. That was the key.

He had to gather his thoughts. He unplugged his phone. There was a knock at his door. Not a ring from the street bell—this was someone in the building. This is how the police must do it, he thought.

Noah calmed down as well as he could and went to the door. The cops were quicker than he thought. He opened the door, and there was the father of his Italian landlord. "We have to turn off the water for maybe an hour," he said with his rough Italian accent.

Why didn't the Italians who came here bring those fabulous accents of Marcello Mastroianni and all the Fellini characters? Noah thought.

"It's the boiler."

"Can I take a shower?"

"Now?" he said looking at his watch as if there was an official shower time for all people.

"I was thinking about it."

"In cold water," the old man laughed. "Give us an hour. Two tops."

"No problem." Noah wanted to say "No problemo," since he likely would never again in his life have this perfect opportunity for it but declined. He closed the door and thought that he wasn't a hunted animal. In fact, most people in the world weren't even aware of McEwen's death.

<center>—◦—</center>

Noah was nervous about watching TV news coverage of the killing. He had no idea how he would react. He was the star of the story, albeit the mystery star. His first reaction was an unexpected detachment. It was the news as always, and he watched it as if he had no part in it. His name wasn't mentioned. The first speculations over who might do such a thing didn't come close to describing a person like himself. As the story

continued with its lurid detail, a self-satisfied smugness set in. He realized how those who capitalize on these events with their analysis and speculation consistently get it wrong. How each creates a self-serving narrative out of disconnected and messy facts. After all, stories sell; messy facts don't. Noah remembered how he had felt watching live as the second plane on 9/11 hit the second World Trade Center Tower. The slicing impact of the plane entering the building had hit him in the gut. He, like everyone else watching on TV, understood that those on the plane were instantly dead. This was a narrative he had been prepared for and feared every time he flew. But the buildings' collapse was different. He was not prepared for the consequences of that one. He had been in hundreds of apartment and office towers and had never imagined what he was looking at on this day. It was a spectacular image, and when the buildings went down it wasn't thousands of people dying in front of his eyes as much as it was a mind-blowing spectacle. He couldn't imagine the people inside. There wasn't yet a human narrative for this image, and without a narrative there was no emotional connection. In the McEwen case, which didn't happen live on TV, there was time for the news to manufacture its own narrative.

The police investigator in charge of the case "could not imagine the kind of mind that would perform such a horrific act."

"You can't imagine him?" Noah asked aloud. "He's like you and me. Two arms, two legs, likes to get laid and can't pay his bills. Welcome to the land of the unimaginable, asshole."

A guest psychologist claimed that "the number of seemingly unprovoked blows from behind with a weapon like a machete could indicate a person with a psychotic major depression, or PMD, which affects 0.3 per cent of the population. Many of these people experience delusions. For example, a person with PMD may kill another person because he or she believes that person is the devil."

"And what if I had a moment of fucking cosmic clarity—not a delusion, but the polar opposite? That's a narrative you can't sell, right, fuckhead!" Noah yelled at the TV. He clicked it off and flopped back onto his bed. He thought about the horrors he had seen on TV and how they were turned into "stories" that the audience would buy. A 747 heading to Singapore crashes and kills hundreds on board. The TV shots of screaming and grieving relatives at the airport waiting to hear

the names of loved ones lost. What we never see, Noah thought, is the woman in that crowd at the airport saying to the TV camera that her husband was on a business trip with his secretary and he was screwing her and they both had died on that flight and "I couldn't be happier." Noah was sure that this had happened at some time somewhere but had never reached our living rooms. He thought about many things except the crime he had committed and that he was guilty of murder.

He pulled the covers up to his chin and stared at the ceiling and thought that if he stayed just like this in bed, no one would ever get to him. He fell asleep.

———◆———

Noah woke up three hours later with a thought already buzzing in his head. It had passed over from his dream to his waking world. He didn't want to open his eyes. He didn't want to return to consciousness. The thought went back to the TV shrink and his clinical definition of psychosis. Noah had always imagined the gap between sanity and insanity to be a vast no-man's land like the complex of walls and wire and cameras and searchlights and electric current that divided Cold War East and West

Berlin. But now he realized that the gap was no wider than a chalk mark that could be crossed with a forehand tennis stroke. Sanity and insanity, he now thought, lived cheek by jowl and allowed those on either side to pass freely without questions or papers. In Noah's case, all it took was a decision to cross the line. It was simply a matter of will.

Curled up in his bed, the murder had no moral context for Noah. It was, for him, the result of his action rather than inaction. That was its sum total. He had made a decision and jumped in. His mind wandered to his childhood on the dock of the family cottage and how his cousins would dive or leap into the cold water in the morning and he would take forever to lower himself in down the ladder, feet, knees, thighs, stomach. "Just jump in!" the others screamed. He had jumped in.

<center>•——•——•</center>

Noah decided to contact the police about his squash date with McEwen. They would most likely come to him, but he thought it better to volunteer. After all, he had left two phone messages on McEwen's voice mail to show his innocence regarding McEwen's absence. He

called the police station closest to the university and was
connected to the detective in charge of the investigation
who asked Noah to come in for an interview.

Noah showered and shaved. He wasn't sure what to
wear. What do you wear to a police interview? Should
he wear his suit and tie? Respectable businessmen wear
suits every day. But if he told the police what he did for
a living, which was almost certain to come up, and of
his present unemployed circumstance, they may won-
der why he wore a suit. Was he trying to impress them?
Was he trying to throw them off? His other clothes were,
under the close examination he had never given them
before, too shabby and made him look, in this context,
like a possible criminal. He decided on his suit pants
and a crisp white shirt, no tie. In the mirror he looked
unlike himself, as if he were in costume. This gave him
an odd kind of confidence to play a role.

Riding the subway to the police station, Noah
thought how this interview was so much bigger than
anything anyone he sat with on the train would ever
know. He wasn't like a person who had just been told
by his doctor that he had a terrible disease. He wasn't
like the guy sitting across from him, who very easily
could have just received the bad news. The guy was

around fifty and wasn't reading or looking at anything or carrying anything, just sitting there with a dead expression, rocking back and forth with the motion of the train as if his body had given up hope. Noah had, as the saying goes, been given the ball, and how well he played the police would determine his future. He had never before been a player when the stakes were so high.

"There are two cameras, one behind me, and one behind you," Detective Hopwood said, pointing at the cameras on the walls just below the ceiling. "We tape all our interviews, so don't think this is anything out of the ordinary. I'm going to get myself a coffee. Can I get you one too?"

"No, thanks. I'm fine," Noah said as Hopwood left him sitting alone on one of the two hard chairs. He was sitting on a chair that he was certain had been sat on by innumerable criminals, and he wondered whether the coffee routine was a standard test and whether Hopwood was watching him on a monitor in another room, looking for some kind of body language that might give him away. He tried to behave normally and quickly realized that there is no such thing. He looked at his right hand resting on the table in front of him and

started to drum his fingers, and then, thinking that this might look theatrical, something someone might do in a movie, he stopped and folded his arms, still looking at the tabletop. He then thought that Hopwood had pointed out the cameras, and that any normal person would feel odd sitting alone with that knowledge and would likely look up at them, so he looked at the camera in front of him and had turned in his chair to look at the camera behind him when Hopwood returned.

"That one gets a wide shot of the whole room and this one is a tighter shot of you. They're for recording everyone we talk to. It's easier and more thorough than notes. I hope you don't feel like you're a suspect."

"No, no," Noah replied. He could feel the sweat begin to dribble from under his arms. "I've never done anything like this, but I have some idea of the procedure. I'm a writer on a police TV show."

"I know the show. I've seen your name on the credits."

Hopwood didn't say whether he liked the show or not. What if he hated it? What if he had seen some of the episodes Noah had written that attacked the police?

"I'm not on the show anymore. Also, cop shows aren't my thing. It was just a living." Noah used the informal "cop" rather than the more formal "police,"

which he thought would signal to Hopwood that they were both on the same side.

"We have Mr. McEwen's voice mail. You called him twice the night he was murdered."

Hopwood stopped without asking a direct question and Noah didn't know whether to answer or not. He thought that interrogations, in part, came down to punctuation, and there was no question mark at the end of Hopwood's remark. Was this bad English, or was it bait?

"Yes, I called him."

"Why?"

With this unadorned, single word, it was now clear to Noah that Hopwood had been bullshitting him. Hopwood had dropped his easy-going approach, which had both him and Noah on the same side, and revealed his real intention. Noah now knew he was a suspect.

"I wanted to tell him I was at the gym. We had arranged to play squash at eight and I was supposed to meet him there around 7:45 so he could get me in. I'm not a member. I have been, but I let my membership lapse. When Patrick didn't arrive on time, I talked the student attendant into letting me go in and change and wait for him on the court. They usually don't allow that,

but it was eight and the gym closes at nine and I guess she figured no one else was going to take the court at that hour."

"You made another call."

"Very good," Noah said with a bit of a laugh. He wanted to compliment Hopwood but it came out as clumsy and condescending and Noah could hear it echo in the room. Did he just reveal that he was capable of setting up an alibi? He lowered his voice and took a deep breath, shaking his head as if to ponder the horrors that are possible in civilized society. "This is an incredibly horrible and gruesome thing." He was expecting Hopwood to agree, but he said nothing. Had he changed gears too quickly? Had a large chunk of scenery crashed to the stage in mid-performance? Was this the way he would have written the scene in one of his cop episodes if his character was in fact guilty? "I called Patrick from the court about fifteen minutes later, since he still hadn't shown up. I guessed he had forgotten or something more important had come up. I didn't want him to worry about not making it. So I called to tell him I was hitting the ball around by myself, and if he couldn't make it, no sweat. I hit the ball around for another few minutes then changed and walked home. I don't get uptight about those things."

"What things?"

"About people missing appointments. You can't take that personally. You have to be reasonable."

"You had a fight with a student at . . ." Hopwood checked his notes. " . . . McEwen's book launch. This was an event to . . ." He again scanned his notes. Noah helped him out.

" . . . launch a newly published book. It's for friends of the author and the people who published the book and others in the literary community as well as people the writer and publisher might want to suck up to." Noah chuckled at his last remark. Hopwood didn't. "That's an inside thing," Noah said. "The literati—it's a bitchy business." Noah wondered if this sounded gay. Would Hopwood now consider the possibility that both he and McEwen were in the closet and having an affair that had soured? This had been a plot point on an episode of his cop show, and now this scene was also beginning to sound scripted to Noah. If it was a script, he and Hopwood were actors, and the actors know the ending. Sweat from under his arms continued to stream down his sides.

"'Bitchy business,' meaning . . . ?" Hopwood asked.

"Meaning there's a lot of competition."

"Got it," Hopwood said with a smile.

Suddenly, and simply from this turn of the phrase "Got it," Noah had the sense that he and Hopwood got each other. He now felt he shouldn't have jumped to the conclusion that he was a suspect. Hopwood's earlier abrupt question may have been nothing more than his need to get through the drudgery of a day's work.

Noah relaxed back in his chair as much as was possible with the kind of chair made to put people on edge.

"Can you tell me about the fight?"

"At the book launch?"

"Was there another fight?" Hopwood asked without any irony.

"No, no." Just as quickly as he had relaxed, Noah realized that Hopwood wasn't a friend but was looking for any misstep or inconsistency and he shouldn't get drawn into a relationship with him that went beyond cop and suspect. Anything else could only work against him. That was the real game and Noah understood he mustn't forget it. He now had no friends. That was the rule he had to follow. "The kid was drunk and wanted to disrupt things. He was pissed off about how McEwen had treated him in a class. He was out of control. When I tried to shut him up, he kind of came at me. I'd also had a few. I pushed him back and he fell into the water. I

wouldn't have called it a major battle. I just didn't want to see McEwen's night ruined."

Noah guessed Hopwood had known about the fight from one of the smokers who had witnessed it. The cops probably had the student he pushed into the water pretty high up on their suspect list. Maybe even alone on their list. Noah was certain that his own actions at the book launch had convinced Hopwood that he was not a suspect, in fact the opposite: he was a close friend who would defend McEwen's reputation with his fists.

When the interview was over, Noah stood to leave. "I sweat," he said.

"What?" Hopwood replied, genuinely uncertain of what he meant.

"Under my arms," Noah said, indicating how wet his shirt was and feeling he had to explain it.

"I didn't notice." Hopwood smiled.

Noah had opened up a small can of worms, but one he felt had to be explained. "I walked here, and when I come inside an air-conditioned building from the heat, I have the kind of physiognomy that sweats." Noah wanted to stop talking and get out, but it wasn't his nature. "I'm a big sweater, always have been."

"Doesn't physiognomy refer to the face?" Hopwood asked as he moved to the door.

Noah honestly didn't know the answer, and he suspected Hopwood could be right and that he had been beaten at this semantic game by a cop.

"Maybe it does. Good call," Noah said as if they had been in competition and Hopwood had won. This was exactly the relationship Noah didn't want. He didn't want to start a cat-and-mouse game and have Hopwood thinking about him.

"Here's my card." Hopwood handed him a business card and Noah thought how things have changed, how everyone now wanted to be in business. Noah could imagine Hopwood saying, "I'm in the murder business."

"Call that number if anything else comes to mind or you hear anything we might be interested in."

"For sure," Noah said. "It was nice meeting you."

Hopwood didn't reply. They each went their own way.

—◆—

By the time he was on the street, Noah was convinced that the worst Hopwood could think of him was that

he was intellectually competitive and slightly insecure, which was a much better impression than that of a machete-wielding madman.

The day was bright and warm, and Noah felt like walking. He wanted to see how his new relationship with the world felt. The people he used to envy—the businessmen with their attaché cases, the businesswomen in their heels, all of whom before had moved with a purpose that he couldn't understand—now appeared different to Noah. Now they appeared like robots moving on defined tracks, repeating their plotted routes day after day for no other reason than that they had done it the day before. None of them would change the world. All were what used to be called Spear Carriers in his drama club at college. Noah had been a Spear Carrier in *Julius Caesar*. He had had no lines. He had watched from his background mark on the stage as Ian Frazer played Brutus and then, in the years after, read in the business section of his newspaper how Frazer moved up the corporate ladder to head one of the top four banks in the country. Now, walking the streets, Noah felt he was no longer a Spear Carrier. He was different from every person he passed. He was a Brutus in a real drama. He had, in his mind, taken on Shakespearian

proportions. He was a warrior in his own war. Why did he have to go by other people's definition of war? After all, one person's warrior is another person's terrorist, he thought. Everyone defines war to suit his or her own needs. Fighter pilots who dropped their bombs on Iraq were "heroes." Iraqis who blew up transports with roadside bombs were "terrorists." It had been this way since the beginning of human history. Why couldn't he be an "assassin" rather than a "murderer"? Why couldn't he define *his* war? His war wasn't with one of the tyrants of the twenty-first century, but with the century's false gods. His was a war over their degradation of the culture. And why was culture any less important or less coveted than land or gold or oil? Why did war have to be a world war, or a war between countries or a civil war? Noah had decided to go to war alone and with his act define his place in the world.

11

The Path of Duty

Every morning now when he woke up and before opening his eyes, Noah's first thought was "I am a killer, I am an assassin. There is no turning back, no denying it." His old life paled in the face of what he now was. His petty vanities, his useless competitiveness, his deluded ambition to make it in a world he held in contempt, his exaggerations about what he knew, his lies about what he had read, his failure to give attribution for ideas he had read but spouted as if they were his own, and for every one of these weaknesses, his guilt—*that most corrupt and corrosive method of payment for our transgressions*—all of it had been left so far behind it was hardly visible in the killer's rearview mirror. All of it had withered away. The word *wither* reminded him of Marx and

Engels and their idea that in the ideal communist world, the state would wither away. The people would see the light in the soul of pure communism, and the rules and laws that had established it would no longer be necessary. And Noah thought that everything false about him, everything that had defined him in the past would, through his act, wither away and he would become only who he was, the killer, the assassin. He opened his eyes and remembered a quote he had written down years ago and taped to his wall of ideas. Hoping he hadn't destroyed it in one of his attacks to eliminate his past, he got out of bed and flipped through the papers still tacked up, some of which had, over time, been buried under others. He found it. There was no attribution and he couldn't remember where it came from: "Although your life is made up of thousands of days and incidents, they can all be reduced to one moment, the moment when you know who you are, when you see yourself face to face. When Judas kissed Jesus he felt at that moment that he was a traitor, that to be a traitor was his destiny, and that he was being loyal to that evil destiny."

Noah crawled back into bed and stared at the ceiling. He wondered whether these eloquent notions had any reality, or was he simply justifying a horrific crime

with a semantic slight of hand. Was all of it just intellec-
tual gamesmanship? He had read Camus' *The Stranger*,
and a significant amount of *Crime and Punishment*, and
he wondered whether any criminal act could be justified
with a talented play of words.

He wanted to stop thinking. He wanted to go back
to sleep and wake up fucking Andrea Scott, "the no fuss,
no muss woman."

He gave her a call.

The sexual fantasy Noah associated with Andrea Scott
never came close to his obsession with the fifteen-
year-old's orange-half breasts but had taken on a more
adult character. Here was, by any upper-middle-class
standard, a happily married woman with three healthy
children and a successful and wealthy husband, a mem-
bership in a golf and tennis club, a two-and-a-half-
million-dollar home and an island with a cottage on
it in the Eastern Townships, and she would risk it all
to satisfy her hunger for sex with Noah Douglas. All of
this supported his belief in the vacuity of the Amer-
ican way of life while it confirmed his own masculinity.

After stepping through his door, Andrea seemed to know the right time to slip out of her expensive clothes and crawl into his bed. The right amount of chatter, the right amount of nervousness, the right amount of indecision, all of which added up to an exquisite sexual tension. The sex was better than the last time. When they were finished, she asked if she could smoke a cigarette in his place and he said he didn't mind. She dug a new pack out of her purse and asked if she could leave it behind because she never smoked at home. He said again that he didn't mind. While they lay in bed and she smoked, he thought of the movie *Belle de Jour* and wondered if she knew he was a killer would she become more sexually aroused. Would she react to him like Catherine Deneuve reacted to the thug with the gold tooth, to his brute criminal-class behaviour? It was clear what Andrea wanted from him: she wanted something illicit, something that denied the life she had, and it was embodied in sex and cigarettes. Was she locked in a struggle with herself, perhaps not unlike his before the killing? She put out her cigarette and rolled over next to him. "I must smell of cigarette smoke."

"I like that," he said. What he didn't say was that it reminded him of his mother, because that is the last

thing a woman wants to hear after an orgasm. He considered, for one crazy moment, telling her that he had killed McEwen. That might make this the sexual relationship it was meant to be. His confession would put them smack-dab in the middle of a real-life *Belle de Jour*, and his killing would realize its essence as a work of art. But while he believed in a spiritual need to experience art, art is not life; it is something very different from life and if it weren't different from life it wouldn't be art. *Belle de Jour* belongs on the screen, not in my apartment, he told himself.

"What are you thinking?" Andrea asked him.

Christ, he hadn't heard that question in bed after sex since university, and he realized that whatever Andrea's struggle was, it certainly wasn't a heavyweight fight like his. He remembered how his father often quoted Thoreau's line, "The mass of men lead lives of quiet desperation," and how this was Andrea. This was what his father had feared most in his own life, and his only salvation was his unwavering devotion to Noah's mother. When she died and he died of a heart attack just ten months later, his death was no surprise to Noah.

"I'm not thinking anything in particular," Noah replied.

"I'm thinking about why I'm here," she said in an unexpressive tone, as if she were laying the foundation for something bigger to come.

"Maybe this conversation shouldn't go there," he said. "What I mean is, this works because we don't go there."

She didn't say anything more for two or three minutes. Then she said she'd better go.

———◆———

Noah put on his only suit, which was now beginning to feel like his dedicated funeral attire, since funerals were, of late, the main occasion for it. He left his apartment to walk the forty minutes it would take to get to the McEwen funeral. He tried to enjoy the mild spring air and not think of the pure madness of his situation, attending the funeral of the man he had killed. This was another act he would have to perform as the "new Noah." The role required an outward sincerity and an inward deceit. Or was it the other way around? He would treat it like the time he went to a cousin's wedding on acid and all his relatives turned into people out of a Dickens novel, which included Mrs. Haversham

and her cobweb-covered wedding cake. On the inside reality had completely collapsed, but on the outside, as he heard later, he was quite sociable and funny.

He passed a panhandler sitting cross-legged next to the curb with a dirty paper coffee cup held out. Noah gave him five dollars because he felt that any less from someone in a suit would look cheap.

"That'll get you into heaven," the panhandler yelled after him as he kept walking. But Noah didn't give panhandlers money to get to heaven; he did it because of who they were. Not because they needed it but because they deserved it. For him the panhandler could only be who he or she was. Why be a panhandler when you're really something else—when, for example, you're secretly a person of means? It was the people who played their roles who he resented and hated. The hypocrites who cultivated professional lives and reputations, which they believed defined them, when, in fact, many of them were more than capable of deceit, theft and perhaps murder. Noah wasn't a religious person, so heaven wasn't on his agenda and neither was morality. His social concern was the face and the real person behind it, and almost everywhere he looked he saw fraudulence. The frauds he hated most were the successful frauds, because

their success made him jealous and he hated most of all his own jealousy.

There was no morality, he thought; there was only the struggle to be truthful.

———————

Noah arrived at the church and signed a guest book, which had a space beside each name for short comments about the deceased. No matter how macabre his situation, he couldn't help but think how funny it would be to write, "He didn't die easily. I virtually had to hack his head off." He signed his name and next to it wrote, "A tragic loss, a remarkable man."

Noah took a seat and nodded to a few people who he knew. The organ played, lulling everyone into that mourning rhythm that unifies all in common grief. He looked to the front where the coffin sat. During both his mother's and his father's funerals, no matter how hard he stared, he had not been able to imagine a body beyond the heavy wood of the coffin. Somehow the coffin did a miraculous job of isolating death from life, and the result was that funeral ceremonies were all done in the abstract. The actual body was never an issue. Whoever was inside

the coffin had not only passed away but had passed from reality to hagiography. The ceremonies were all about selective memory or pure fiction, and Noah, on these terms, was able to join the chorus. None of the comments of love and admiration expressed by family and friends made Noah react any differently from anyone else. Some comments were touching; others were bullshit. This was like any other funeral, where everyone in the audience keeps his or her own secret scorecard.

Outside the church after the service, Noah expressed his shock to McEwen's closer friends, chatted socially with others about crime rates and the "thin layer of civility" in our "supposedly civil society" and avoided a trip to the cemetery because of a doctor's appointment which he characterized as "important," but said he would be at the house in the evening.

———◆———

At the house things were not what Noah expected. This was not just any funeral. This wasn't an old person who had died, or a man who drank too much and smoked and went down with a massive heart attack, whose death was just another chapter in a high-risk life. This was the

victim of a "bloody, sensational, inexplicable murder," and no one had a clue why it had happened or who had done it; a tense pall hung over everyone because no one really knew why they were there. Not a soul could imagine where this death had come from, but there was still a quiet buzz of speculation, and every passing glance gave Noah a chill. He had a number of drinks, but the drinking only increased his paranoia. Were people watching him and whispering among themselves about him? He started to sweat under his suit, and even the most innocuous conversations became difficult for him to follow as he read insinuation into every comment and suspicion into every look and smile and pause in speech. He had to get out. He got the attention of McEwen's ex-wife, Janice, so he could express his condolences and leave.

"This is like a bad dream. Inconceivable," he said to her.

"You were supposed to play squash with him that night," she said without finishing her thought. What she didn't say was "Yes, it is like a bad dream." She seemed to tilt back and look at him waiting for a response. Had she made a statement or asked a question? Did she expect him to flesh out his story about

the squash game, perhaps add something new, something the police didn't already know? She must have heard about the game from the police. But why would they raise it with her unless they considered it to be a piece of the crime's overall picture?

"I was supposed to meet him at the gym, and when he didn't show up I called him twice but got no answer. I didn't think much of it other than he had forgotten, and when I heard the news in the morning, well . . . God . . . I mean . . ."

"I know," she said, looking down at her feet, again without finishing her thought, or, for that matter, even expressing a thought. She didn't say anything else, and Noah felt trapped by the silence like an insect stuck in tree sap. He knew he had an expression on his face but couldn't tell what it was or what it said.

"I have to leave," he said. And, without a handshake or a kiss or any response from her, he was gone and on the street walking as quickly as he could. He started to run. He was in a suit and heavy leather brogues but he pushed himself. He wanted to feel pain. But for what? He got to the point where his lungs were bursting and his feet were sore and his shirt was soaked with sweat. He was now on the main street that led to his apartment

and he had to stop and get his breath. People passed him walking in both directions as he leaned over, his hands gripping his thighs. The odd one looked at him, but strange behaviour was not unusual on this strip and he must have looked like just another guy who had had one too many. He started to walk again. As he looked at people he passed, he no longer felt like the tragic Shakespearean hero amidst the crowd of minor players with insignificant roles. He was no longer the unique assassin, or the killer. He now felt that this wasn't his nature but that he had invented it all to justify his crime. In fact, he had committed a monstrous and sickening crime. He felt a deep chill and his soaking shirt made it even worse in the cool night air. He found himself shivering. A terrifying loneliness seemed to throb through his veins with every pulse beat. He had never imagined that loneliness could be physical, and he felt like he was sinking into a place he didn't recognize and couldn't describe and he thought that this must be what it is to go mad. "This is where you go," he said to himself with the morbid fascination of a crazed scientist from an old horror movie. As he walked, the new place started to come into a strange, vague focus that defied the senses. He couldn't see it or hear or touch it but it was there,

some deep crevasse between his old self and the killer he thought he could be. It was a place he couldn't describe, with a language he couldn't understand. And his alienation from this place was complete. He was a stranger in this place, a new arrival. This was the place of the truly insane, he thought. But he knew he wasn't insane and he was there by some horrible mistake and he was alone and there was no help, there were no friends, no enemies either, and it was so dark and deep that he could barely see the light of the real world or hear its sounds. The conversations and screams and laughter of the real world had become a faint, muffled gibberish. As he walked, like the crazed scientist, he let himself go deeper and deeper into this place. Would he just keep going until he disappeared? How do you function from day to day in this place? What do you do for a living here? "Maybe politics," he joked out of nowhere. And it was this joke that jolted him like an electric shock. It was the joke that reminded him he still had a mind. But what was the role of a mind in this place? He was now literally terrified.

"Noah!"

He heard his name and thought it was ringing in his head, some ephemeral self calling from his prior life.

"Hey, Noah!"

He turned to his left and saw a man and a woman crossing the street through the night traffic. The man was smiling and they were coming toward him.

"Hey, this is crazy," the man said. "I haven't spoken to you in over a year and two hours ago I left a message on your machine and now I run into you on the street."

It was Jeffrey Lawrence, a slightly slimy TV producer Noah had worked for in the past.

"Sarah Bemalman, Noah Douglas."

The woman, who was at least twenty years younger than the producer, smiled and thrust out a hand. Noah shook it and thought how so many men of Lawrence's age had to fuck younger women. It seemed epidemic. Was it another virus that had leapt from monkeys to man?

"That murder, that guy Patrick McEwen, you knew him, right?"

"Yeah."

"Fucking horrible. Scares the shit outta ya. Did you know him well?"

"Well enough."

"I'm sorry. Horrible. Look, I called you because of *Always Running.*" He turned to the girl and explained

that *Always Running* was a series idea he and Noah had developed and pitched but no network wanted a political show in "this climate."

"It was a great fucking idea. A satire of the inner workings of government bureaucracy, *Catch-22* in politics. They were insane to pass." He pulled out a pack of cigarettes and turned back to Noah. "Now we have a buyer who's very interested, and I called you because I know you got dropped by your show. I still smoke." He offered one to Noah, who accepted. Lawrence lit both.

Noah had smoked from time to time in his life while drinking but stopped because of a high blood pressure scare. However, at this moment he wasn't particularly concerned with his physical health.

"They want one scene that shows your kind of humour." To the girl, "Politics scares everyone, that's why I love this. Noah is fucking great at it." To Noah, "Can you write out that scene you used to pitch where the incumbent is shot? If that scene works as well on paper as you pitched it, I think this is a slam dunk."

Noah had taken a couple of drags and very suddenly became dizzy. He didn't answer Lawrence and took a clumsy step backwards, then turned to walk away and

weaved, then tripped and fell to the pavement. Everything went silent and into slow motion. He knew he was lying on his back and could see Lawrence over him saying something and the girl standing behind Lawrence looking down with a concerned expression, but he couldn't hear a thing. He felt heavy and as if his body was sinking into the pavement. He thought he should say something like "I'm okay" but didn't feel like it. For a moment he thought he could will himself to keep sinking until he completely disappeared, then everything would be over. He saw Lawrence dialling his cellphone and he closed his eyes. The next thing he knew he was on his knees and he could hear Lawrence repeating, "Are you okay?" as he helped Noah to his feet.

"I'm fine. It was the cigarette. I had a lot to drink. The two together . . ."

"Fuck, we thought you had a stroke or a heart attack. I called an ambulance. I think you should go to emergency."

"No! Why did you do that?! It was the fucking cigarette! Call them back! Cancel it!"

"I think you should get checked out."

"I'm okay, I swear! I'll write the scene if you phone and cancel the fucking ambulance!"

Lawrence agreed. Noah knew that, like all producers, he could be negotiated with. Without another word, Noah turned and walked away.

12

Suspicion

Noah woke up to his ringing phone. Like most mornings, his first thought was "I'm a killer." This morning it was a sickening thought and the caller deepened his nausea. Detective Hopwood wanted to know if he would be available for a coffee in the afternoon at a place near Noah's apartment called Buena Bean. Noah agreed to meet him, hung up and flopped back onto his pillow and stared at the ceiling. How did Hopwood know where he lived? He hadn't given his address in their first meeting. He realized that Hopwood knew more about him than he had thought. And why coffee? Why not meet in the station again? Was this a set-up, some kind of chummy cop trick to lower his guard?

Hopwood squeezed the lemon rind over his double espresso. "I like this place. I'm not a shitty-coffee and doughnut cop."

"I guess the cop and doughnut thing is a bit of a myth," Noah said.

"Unfortunately, it isn't," Hopwood said as he sipped his coffee. "There are a lot of dumb, fat cops who love their doughnuts. I'm no genius, but I try to control my weight. I played junior hockey before I became a cop. I was always in good shape and wanted to stay that way. But it gets harder every year. I'm a good fifteen pounds over my playing weight."

Was he letting Noah know that he wasn't a dumb doughnut cop but a smart double-espresso cop who had Noah in his sights? Was this casual meeting Hopwood's way of narrowing the plank that Noah had to walk?

Noah was suspicious of the whole conversation and waited for the real agenda to reveal itself. Hopwood finished his espresso and sat back. He put both hands together as if in prayer and held them to his lips. This was the pose of a man who was thinking. He clearly

wanted to send that message to Noah. He didn't have the answer but he was trying to ask the right question. Noah suspected this non-threatening posture was meant to put him at ease but it did the opposite. It was a cop move and he wasn't sure where it was going.

"I think I have a case against the student you took on the night of the book launch."

The plank Noah now stood on narrowed by a few more inches. Of every possible outcome of his act that Noah had written and rewritten in his head, he had never included the student. He had earlier thought that the student could be a suspect but had never contemplated the implications of his actual arrest. Perhaps his job writing cop shows had had an influence and he could think of suspects as nothing more than actors in a drama.

"I can't put him at the scene with any hard evidence yet. We found a few of his prints in McEwen's office, but he had been there just days before the murder to plead his case for a better mark on an assignment. He doesn't have a solid alibi for what he was doing and where he was at the time of the murder, and his story about the incident at the book launch didn't match that of the witnesses. He also changed his story of what happened

with you that night from one interview to the next. He now claims he was there but didn't get into a fight with anyone. I have a gut feeling that this kid is our killer. He had been in McEwen's office and had seen the machete. He couldn't control his anger, as was evident at the book launch."

"I pushed him. He didn't push me."

"But there was provocation. You didn't just walk up to some quiet student minding his own business and push him into the water, am I right?"

"Yes."

"I need you to help me out here and come down to the station and pick him out of a lineup. I know it was dark, which is working against us, but a positive ID is essential."

Us, Noah thought. What the fuck does that mean? Is he pulling me into this fucked-up investigation, into railroading some innocent kid? Noah had read too many news stories in recent years about the wrongfully accused—men who had done ten and twenty years in prison for murders they didn't commit and all because the cops or prosecution twisted the case to get a conviction. They didn't want justice—they wanted a win.

"Do you think you can do it?" Hopwood asked.

"I think I could identify the guy I pushed."

"This is really little more than a formality. You just have to look at a handful of photographs. I know he was at the book launch, I just want to make sure he's the guy you pushed."

Noah hated the cliché "little more than a formality." He had used it himself in his scripts when he was fucking over the suspect. He thought that Hopwood was more original than that. But who can tell these days whether TV is imitating life or life is imitating TV or even if it matters. Perhaps, Noah thought, it's all one big fucked-up intermingled system of social schizophrenia where reality has become irrelevant and the culture is a rabid animal chasing its tail and gorging on its own entrails.

"Are you free tomorrow at noon?" Hopwood was trying to get the last drop from his empty coffee cup, and before Noah could answer, he interjected, "They roast their own beans here." He didn't say anything else. All these little moves were so obviously the tricks of the trade, the cat playing with the mouse. And even if Noah wasn't, in Hopwood's mind, the guilty mouse, he was to be played, because this is how cops relate to the world.

"Noon should be okay."

On his way home from Buena Bean, Noah realized for
the first time that his crime may not be exclusively his.
No matter how he had previously defined his act, it had
been only in terms of himself. Whatever it was, he had
been solely responsible for it and its consequences. But
now this other thing, this student. This wasn't a conse-
quence he had intended. This wasn't part of "the act."
This was an injustice that not very many years ago he
might have fought against in the streets. Not only would
it be a wrongful conviction but more importantly it
would no longer be Noah's crime. Or was Hopwood's
case against the student all bullshit? Did his real case
have Noah as the killer? Was the suspicion around the
student only a decoy, a trick to get Noah thinking the
way he was thinking at this moment?

Noah stopped in the middle of the sidewalk and
gripped his head between his hands like any other
crazy street person might do. He couldn't think like
this. Every conversation interpreted and reinterpreted,
picked apart like an autopsy searching for the clue that
would reveal not how Noah died but how he would
die. Perhaps this thinking came from the fact that he

had been a hypochondriac from an early age. It had
started with a burst appendix. He had been at the lake
with his family and they got him to the hospital just in
time. From then on any little symptom had scared him.
His family doctor used to say about symptoms, "When
you hear hooves, think horses, not zebras." He tried to
pull himself together. He believed that a good part of
being normal was acting normal. He put his hands in
his pockets and walked and tried to identify the "horses"
in Hopwood's thinking. The student was most likely
Hopwood's main suspect. But why would the student
lie about the fight at the book launch? Why lie when
you're innocent? Why did Noah lie when he was guilty?
He realized how unintelligible life could be when we try
to sort out its truths from its lies and right from wrong.
So we invent systems to address these questions, Noah
thought. The system is nothing more than an intelli-
gible narrative imposed on the chaos of human life. The
Catholic Church was the system in a good part of the
world for centuries. Islam another system, democratic
capitalism another, as was National Socialism in Ger-
many and communism in the Soviet Union. For each
system to work, reality had to be bent to fit its form and
laws written to justify the bending. Noah saw Hopwood

cherry-picking the facts he needed to make his case against the student while ignoring the more complex reality that could push it into the unknown. This, Noah realized, is the justice system.

He remembered reading how Nixon had been forced from office for the Watergate break-in and how this showed that the "American system worked." Nixon hadn't been dumped for murdering a million Southeast Asians during the Vietnam War. They got him for, as Nixon himself correctly described it, "a third-rate burglary." The system worked. What was missed was the reality the American narrative couldn't bend or legalize, a reality the system couldn't have withstood, and that was to prosecute Nixon and Kissinger for mass murder. As he walked, Noah wrote this essay in his head. If the system really worked, why weren't they prosecuted for mass murder? Because the system only had to work to maintain the appearance of democracy. This would allow America to move on without self-recrimination or guilt or responsibility. Hopwood was, Noah realized, only doing his job and looking for a smaller but similarly workable narrative.

———◆———

Noah took a beer from his fridge and thought he might write the scene that the TV producer wanted. But he had no energy for it. The idea of writing something for TV now seemed to him a profound waste of time. Even if it was what he and the producer had called a satire of our political system. As if a satire would change the world, Noah thought. That's the real joke. The notion of satire, which at one time had interested Noah as a political tool, now seemed naive; as if there was something to be said that could make a difference. There's nothing more pathetic than a naive satirist, he thought as he polished off his beer and cracked another, noticing it was his last.

It was two-thirty in the afternoon and a safe hour to call Andrea Scott without the risk of her husband answering. "Andrea isn't home," the nanny said. "Would you like to leave a message?"

"No. It's about reupholstering a couch. I think we can get the material she wants. I'll call her cellphone." Noah called her cell and got her in the middle of coffee downtown with two friends. He had seen women like

her in small groups, well-to-do housewives, drinking coffee at this hour in cafés attached to high-end clothing stores, and he had had no idea who they were or what they talked about. Now, at least, he had a clue. They were Andrea Scott. They had been to the mountaintop and there was nothing there except a heated pool. She told him she couldn't talk and would call him back tomorrow.

It was hot and he had no air conditioning. He finished off his last beer and decided to go down to the pub next door for a cold draft in an air-conditioned space.

———•———

The pub wasn't Noah's scene, although he wasn't sure he had one. It attracted any number of types, from old drunks to the wet T-shirt crowd. He hated that drinkers in this city didn't know their place. It was impossible to find an establishment with true character. People from all over invaded every pub and bar as if their choice depended more on parking than on the character of the room. It was depressing and at times made Noah want to move to Dublin, get a small flat in a half-decent

area and drink himself to death in the corner pub sur-
rounded by regulars. A Brendan Behan without talent;
not a bad way to go, he thought.

He sat at the window bar, which was half a dozen
stools pushed up to a counter where the pub's front win-
dow opened onto the street. People walked by on the
sidewalk within three or four feet of the customers. It
was neither a sidewalk table nor a real bar. It was a con-
cept. Noah didn't like concepts because he could imagine
the conversation between the investors over the "selling
point" of the window bar. He thought how so few things
in the sprawling, developer-built city were truly indigen-
ous. Most seemed born of a marketing scheme. Today,
however, he lacked the energy to make a better choice,
since the difference between all of life's choices seemed,
in his present state of mind, like nothing more than a
"city's best pizza" feature in a lifestyle magazine.

Sitting next to him at the window bar was a drinker
of about seventy with a weathered face, a greying pony-
tail, a plaid shirt and jeans and, in a small-town way, a
worldly aura. This wasn't a guy, Noah guessed, who had
been to Egypt or Ecuador or New Guinea, but the squint
that framed his sharp blue eyes wasn't innocent. It gave
the impression he had seen a certain amount. Maybe

Janice Joplin backstage on acid or a motel dice game that ended with a dead guy. After a bit of chat about the weather he revealed he had worked the Hibernia offshore oil rigs, had done time and had survived prostate cancer. "I'm a cancer survivor!" Noah could not understand the need some people had to associate one's self in this way with the disease—as if cancer was the devil and they had beaten him in the name of good. Hibernia also had no frickin' wife or frickin' kids. No frickin' mortgage either. He was now working at a car wash that handled mostly Mercedes, BMWs, Porsches and Lexuses. "Our brushes don't leave micro scratches on high-end paint jobs you pick up at most other washes. You don't see many Hummers no more in this financial climate and with global warming. That was a nineties, early-2000 vehicle. All about the size of your dick. Ate gas like there was no tomorra. A guy I worked with at the wash used to say they drive Hummers while Rome burns. My choice vehicle is the BMW 5 series. That is, for your dollar, the best vehicle on the road today."

When Noah told him he didn't drive and had no licence, Hibernia snorted a laugh and shook his head. He took another long drink of his beer. "Not a bad idea in this financial climate and with global warming."

Noah downed his cold pint and ordered another for each of them. Sensing that his drinking partner didn't offend easily, he asked him why he did time.

"Stupidity. That shoulda been the charge. Sheer frickin' stupidity. Nothin' to be proud of on that side of things except you pay for it. Then you got these frickin' businessmen, the CEOs, and they don't pay for shit. Society just gives 'em the green light."

"Do you drink here often?" Noah asked.

"Couple times a week. I take the bus south from the wash and pick up the subway on the corner to the east end. Bit of a rough area out there, but not so bad if you're my age. It's kids who get into the gangs. Maybe I shoulda been one of those social-work types with my experience but I don't have the patience to work with kids. Maybe it's because I never had any. And maybe because I never saw a big difference between the criminal and the supposed innocent man. In most situations I experienced it sure as hell ain't no difference of character."

Hibernia was exactly what Noah needed in a drinking partner at this point. Push a button, get a conversation. No need to get involved. A lot like sex with a married woman, Noah thought.

It was after one in the morning, and Noah waited for Hibernia on a bleak commercial street corner under a bright plastic sign advertising "Girls Girls Girls." This was Hibernia's turf.

Two stiletto-heeled hookers in micro skirts stood a few feet away on the curb smoking. Noah didn't even get the standard, laconic "Want a date?" from them and figured he must not look like a john. Johns cruise in cars, hotel rooms on wheels. For these girls, a blowjob, twenty dollars and one more rock of crack was their circle of life. Noah thought they should call this part of town "One More." One more then I quit. One more then I clean up. One more then I go back to school. One more then I get a real job. One more then I go back home.

Hibernia came out of "Girls Girls Girls." They went into a nearby alley, where they did half a gram of coke. High, and drug friendly, Noah said, "I've committed a crime. It wasn't small."

"Don't want to hear about it." Hibernia had another snort and passed the coke to Noah.

"Can I ask why?"

"'Cause we're all alone in the world, my man."

They finished off the coke in silence and returned to "Girls Girls Girls" for another beer.

They drank with two women Hibernia knew, one in her mid-twenties and one around forty. The conversation didn't get much beyond *American Idol* but there were some good laughs and impressions of the judges. Like the coke, the beer got paid for in a random, "This one's mine!" way. No phone numbers or email addresses were exchanged and it was after four by the time Noah got home. He wanted more coke and was coming down hard, so he guzzled two beers in a row and fell asleep on the couch without taking off his clothes.

Noah woke the next morning feeling almost paralyzed. He remembered he had to be at the police station. The phone rang. It was the secretary from the English department where McEwen had taught his creative writing course. At the beginning of the semester McEwen had given her names he wanted as guest lecturers during the session. Noah's name had "Television Script Writing" next to it. The department wanted to finish the course

that McEwen had laid out and wondered whether Noah would be available on the course's last day, May 3rd, at 10:40, Room 200, the Gilchrist Building. His first thought was, would The Hobson Girl be there? His next was that McEwen had given him "Television Writing." Aside from everything that had happened, Noah still read this as a backhanded acknowledgement and thought that in death McEwen was still a prick. He accepted.

<p style="text-align:center">———◆———</p>

Hopwood met Noah at the station's reception area and walked him up to his office. "I watched some of the TV shows you wrote on DVD. Pretty good. I don't watch much TV but I could see you had a different angle than most of the writers."

"I try."

Noah wondered why Hopwood had taken the time to watch his old shows unless he was looking for something.

The lineup was no different from the TV version. But why all the drama? Noah wondered. They knew the student was there that night. Was the lineup really "just

a formality," as Hopwood had described it, or was something else going on?

Hopwood placed photos of six men on his desk. "Second from the right," Noah said without hesitation. "Him." He pointed at the photo.

"You're sure?" Hopwood asked.

"Yes. That's who I pushed into the water." And with this, at least for now, Noah had convicted an innocent man.

———— ✦ ————

He left the station and walked home. Thinking about what he had done seemed futile. What was done was done.

He decided to count his footsteps between the station and his apartment, anything to stop his mind from running through this new complication. But after a few hundred steps counting seemed like the mental activity of a crazy person, or at least an obsessive-compulsive. The only thing that could save his soul—not him, but his soul, he thought—was to bring all of the suspicion and doubt and duplicity to an end. Oh my god, he thought, I'm looking for closure! His snorting laugh

snapped him out of yet another bout of useless torment. This could be the real price I will pay, the unexpected hell, he laughed to himself. I could become one of those people on TV "seeking closure." Noah despised this media invention picked up by so many damaged people clinging to the hope that their troubles can be resolved. As if "trouble" was an infection and "closure" was the antibiotic. He knew from watching enough CNN that closure could never be reached; it could only be sought. The seeking is what gives closure its legs on shows like Larry King. And one can only seek it as a celebrity of tragedy on TV. Closure cannot be sought in private. Noah could hear the producer in the control room, watching his televised confession to murder and yelling at his switcher, "Give me the McEwen photo on his desk drowned in blood! Go to Noah Douglas crying! Give me more fucking tears, Noah!"

There was no closure. There was only the gratification of the viewer's appetite for *schadenfreude*. I don't think I'll go public, he thought, with a smirking satisfaction that he alone could deprive the entire CNN audience of its pornographic fix. "Seven million with one blow!" He took a well-balanced kick at a rock in his path

that finished with his right leg extended and both arms
out. Ronaldo!

That's why they go nuts in Brazil, Noah realized.
That kick. The Saviour on the cross with one leg in your
face. Christ with attitude!

13

Sleep No More

It occurred to Noah that the student suspect was in one of McEwen's courses and could end up in the class he was going to teach. McEwen had taught creative writing for five years, and this last year was also given a course on the short story. Noah emailed the department secretary for a class list. She emailed back a response one seldom gets electronically from a bureaucrat: "Why?" He mailed back that he took public speaking very seriously and wanted to know exactly to whom he would be speaking and that if this was not possible, perhaps they should get another guest lecturer. She emailed him the class list. The suspect's name was absent, but there was The Hobson Girl, "Mary Hobson." He stared at the two words on his screen. "What a perfect name." It may

have lacked the erotic quality Noah remembered of Nabokov's description of "Lolita": three tongue movements; two against the back of the front teeth, and one against the roof of the mouth. Lo-li-ta. But "Mary Hobson" had its own quality. Two marble pillars: "Mary" and "Hobson." This name had no need to explain itself. It was confident and spoke of history. It was a name, Noah imagined, that would live its own life on its own terms. It could choose to carry on a tradition or, like Sylvia Plath and Virginia Woolf, commit suicide and ring the bells of the human condition.

———

His creative writing class was three days away, and since the subject was TV, Noah thought he should watch some. He had never watched the shows he had written, or any other one-hour dramas. So he rented a few episodes of the best-rated drama series, ones that got numbers and critical acclaim. No matter how cynical he was about TV, he still had secretly imagined that the top shows just might be good, or at least okay. They weren't. They were trite and predictable, stuffed to the gills with clichéd characters, morality and philosophy—pop-culture allegories.

Every character symbolized one of a narrow range of
types who supposedly populate all hospitals, all police
stations and most law offices. Every story had the same
idea, the triumph of the human spirit. The individual
who rises above the system that grinds us down. But it
was the bad guys who caught Noah's eye. The irredeem-
able bad guys. The psychos. And Noah was one. They had
the sexy parts. Noah had always enjoyed the bad guys, but
it wasn't until now that he had understood how false they
could be, how little the writers and actors and directors
and producers knew about those characters. What Noah
now knew was that in real life they were not necessa-
ily monsters or madmen or aberrations in the midst of
normality. They could also be part of normality, another
personality within its parameters. In fact, the difference
between a priest and a jockey might be more profound
than the difference between a priest and a killer.

———•———

As Noah walked across the campus to the English
department and the classroom where he would guest-
lecture for the man he had killed, he thought of how
strange this circumstance might appear to an outsider

and how, at the same time, it felt quite normal to him. He thought that "strangeness" must be a function of proximity. When he had seen on a *Believe It or Not*–type of TV reality show conjoined adult twins with separate heads and a shared body, he was, as the show wanted him to be, both intrigued by the weirdness and surprised by how normal the twins thought they were. Now he understood why he didn't feel like a freak doing what he was doing today. If the story of his guest appearance at McEwen's class broke on the news, he could imagine that viewers would see him not only as a killer but as a weirdo as well, who could behave as if nothing had happened. But from Noah's side, what he was doing seemed, if not normal, at least logical. Was he simply learning how to live with his crime? he wondered. And if he was, could this mean that there are other apparently normal, well-balanced and well-integrated members of society walking the streets and travelling the subways and handling our bank accounts and taking our blood pressure and monitoring our stress tests and cutting our hair and selling us shoes and scanning our bowels during colonoscopies, who have raped or killed?

Noah had never taught a class of anything but had also never had a problem speaking in public. He liked being the centre of attention. The more people in the room, the sharper he felt his mind became. He was a performer. He was at his best when the audience had a good proportion of younger women. Women in a room added something to Noah's rhythms, like background music with a solid down beat.

When he entered the classroom there were already half a dozen students seated and Mary Hobson wasn't among them.

"I don't like repeating myself," he said, "so I'll wait for the rest to get here before the introductions." He had brought a couple of books and pretended to scan through them when he was, in fact, nervously awaiting The Hobson Girl and worried that her absence would wreck the day. Mary Hobson then turned up with two male students, all of them talking together about something as they took their seats. She looked up at Noah as if she had never seen him before in her life. Was this an act or was this how twenty-year-olds behaved? He didn't have the time now to pull this one apart.

Noah clasped his hands together and placed his fore-arms on the table, forming a triangle. He leaned forward

and scanned the room, suggesting that he was going to
begin. The students stopped talking among themselves.
"My name is Noah Douglas. I was a friend of Patrick's,
and before his death he had asked me to be a guest lec-
turer. I didn't know him as a teacher, but I knew him very
well as a writer and he was a remarkable talent. I'm not
a writer like Patrick. I'm, let's say, pretty far down the
writer's evolutionary ladder. If you look at a continuum
of writers like that lineup through evolutionary history
beginning with chimps and advancing through Neander-
thals and Cro-Magnons and cavemen up to the modern
writer, I'm the guy carrying the club. I'm the TV writer."
He got a laugh from some and a smile from The Hobson
Girl. No one was looking at him as a killer, and this made
him feel better than he had felt since the act.

"I want to talk about what I think is the basic repeti-
tive theme of all TV drama. First, does anyone have any
idea what that might be?" No one responded. One guy
muttered, "Money."

"That's a network theme. There's no doubt about
that. I was thinking more along the lines of a dramatic
theme." Again, no response. "It's a bit of a trick question,
and I'm not really looking for an answer. I want to talk
about 'the triumph of the human spirit.'"

Noah delivered his ideas about how this concept had corrupted drama. He talked about its political expediency and how it supported the American myth of the individual. He talked about its ability to leave the viewer feeling good at the end of an episode and therefore having a positive association with the product being advertised. He impressed the students. But he had not challenged them. It was Noah's nature to take a combative stance. He finished his TV lecture and paused. He looked at them like a lion scanning a herd of wildebeests for her prey. He felt a need to raise the stakes.

"Who's read *Crime and Punishment*?"

Not a hand went up.

"Who has heard of it?"

There were some chuckles.

"We've heard of it and none have read it. That's okay. It's long, and the last half is pretty tedious. Does anyone know anything about it?"

"Raskolnikov kills his landlady for no reason," said one student.

"For no reason?" Noah replied.

"I don't know. I didn't read it," the student replied and got a pretty good laugh.

"There's something to your 'no reason' reason," Noah said, "but since we haven't read it, I don't think there's any reason to pursue this. Does anyone have any thoughts about public broadcasting?" No reaction. "Nothing?"

"I think it's a good idea," said one of the girls in a flat tone, as if she had been asked whether she liked white cats more than black cats.

"Good how?" Noah asked. The student was momentarily lost. Noah helped her out. "Can you expand on your remark, 'I think it's a good idea'?"

"They do shows about the environment." She didn't feel the need to go beyond this insight.

It had been twenty years since Noah had attended a university class and he didn't remember his fellow students being this blasé about their own ignorance.

"Okay, now that we've covered the environment and *Crime and Punishment,* let's talk about why public broadcasting is important." He looked at The Hobson Girl and could see that he was losing her along with the rest of the class. This was not going to be a fruitful direction, and he wanted to get out of the class with some dignity. He looked around the room as sweat began to collect under his arms. The picture of his murderous attack on their

teacher flashed in front of his eyes. He was exhausted by this relentless vision. He wanted to fight back. Murder was one of man's defining traits, one of those anthropological features that separated him from other primates. He had simply carried out a human act. And he wanted someone else to share his burden, if only for an hour. So he took it out on the class.

"The popular culture is fucked," he said, "and you eat it up like pigs at a trough." A few heads rose from their resting position. "I don't think you assholes get it. I'm sorry to call you assholes, but that's the way I see you. Why are you all here? You think this is a creative writing course, but not one of you in the last thirty-five minutes has shown me a hint of creativity. Not even a good put-down. I've had better conversations with twenty-dollar hookers and at least walked away with a blowjob. All I get here is mindless arrogance, as if you know what the fuck is really going on out there." A number of students stood and walked out. Noah ignored them and kept going. The Hobson Girl sat. "But the truth is—and I won't get into the concept of 'truth' with you because that would be like discussing quantum mechanics with a class of ballroom dancers—but the truth is you're all privileged brats who have seen nothing in life and whose parents

are paying to support your self-indulgent delusion that you have something to write about." A few more stood and left. "My guess is—and this is only a guess, I could be wrong—that none of you have sweet fuck-all to say about anything. Any comments?"

The Hobson Girl's face showed nothing. The rest who were left, the same.

"I think the class is over," Noah said.

As they filed out, Noah stopped The Hobson Girl.

"Ms. Hobson, could you wait a minute?"

"I have another class next period."

"This won't take long." She stopped at the door. "You didn't walk out with the others." She didn't respond. "Patrick thought you were very talented. I'm developing a TV series, a political satire, and would be interested in some input from the demographic the network is targeting and you seem to fall into that range."

"I should get going."

"Would you consider working for a while as a creative consultant?"

"A what?" she asked with that sharp, incredulous tone that only a twenty-year-old smart-ass girl could muster.

"You're the demographic. Don't take it personally," Noah said with a grin. "At this point of development it

could mean anything from comments on story ideas and characters to reading scripts and giving notes. You don't have to know anything about the business but you do have to have an opinion, which I suspect you have about many things. I'd have to run it by the producers who would pay you, but I think they'd like the idea."

"This is kinda weird. I have to go."

"Why don't you think about it? I'll talk to my producer and you and I can talk later."

The Hobson Girl took a breath then puffed out her cheeks. She wasn't accustomed to this kind of pressure. Privileged girls aren't used to pressure. "Okay," she said and turned and walked out. Noah had made a promise he couldn't necessarily keep. But he'd play it a day at a time, which was the strategic pattern his life had fallen into anyway. He sat in the empty classroom for a few minutes and wondered what he was after with Mary Hobson. Were his instincts just male reflex, or was there something in her that genuinely interested him? Was he still in competition with the dead Patrick McEwen? Was this McEwen's way of haunting him? In the past he might have sided with the conventional wisdom regarding student/professor relations, but any ethical measurement of his recent action was so far off

the charts that sleeping with Mary Hobson would be like getting a moral parking ticket. He wanted to grab her bare ass with both hands and press her nude body into his. Was this a worthwhile ambition? Was it worth the risk and potential collateral damage? Where did this struggle, which had been going on since the dawn of man, fit in the progress of human history? Marx had said that the progress of history was manifest in the struggle between the classes. Noah thought that his struggle for sex may not move history but perhaps it was the only meaningful struggle he, as an individual, could undertake.

Noah stood, gathered his things, left the classroom and walked down the hall to the wide glass-walled staircase that led from the second to the first floor. As he walked down two male students flew by him two steps at a time, backpacks stuffed with books swinging from one hand. Each jumped the last five steps onto the landing, made a hard left and flew down the last flight of stairs, making the same leap at the bottom onto the polished stone main floor. Seeing this, Noah realized that the

students in the class he just finished were no different from these two. They were kids. They weren't young indulged adults; they were kids being asked to act like adults. Some probably thought that they were being asked to be Raymond Carver or James Joyce. Noah thought he would have had the same expectation at that age sitting in that class and listening all year to imperious speeches from a Patrick McEwen. Why should they know anything about anything? They still wanted to jump the last five steps, and Noah felt like a fool and a pretentious bully for his closing outrage.

He walked out of the building into the sun and passed one of the female students from the class talking to two other girls he didn't recognize. When he passed she glanced at him and kept talking quietly, and it was clear that she was telling the others what had happened in the room and that Noah was the guest lecturer. He kept going as if he didn't notice them and could feel three sets of eyes focused on his back. Were they only talking about his performance, or were they speculating as well that perhaps he was the one who had killed McEwen? He picked up his pace and didn't feel any relief from this paranoid question until he had turned a corner and was out of sight. As he walked down a residential street that

bordered the downtown campus, Noah looked down
at the sidewalk and thought how it was the same as the
sidewalk on the street where he was born and raised.
There were about four feet between the lines that separ-
ated cement sections, and he remembered how well he
knew each crack and flaw and variation no matter how
slight on every inch of sidewalk on his entire block. And
he was thinking how kids spend most of their time look-
ing down at the ground when the memory of McEwen's
body again exploded in his mind like a stroke. McEwen,
not yet dead but slumped forward onto his desk, his
collapsing heart rhythmically spewing blood from the
wound in his neck as life drained from him. What Noah
couldn't grasp was how these two memories, the sidewalk
from his youth and McEwen's dying body, could coexist
in one mind. He felt as if another person had invaded his
body. He started to sweat and found it hard to swallow.
This was yet another one of the creepy feelings to reach
out from nowhere since the murder and grab him by the
neck. He picked up his pace and turned onto the closest
commercial strip, went into a bar and ordered a cold pint
and a double vodka. He downed both in about two min-
utes, ordered another pint and began to calm down. He
grinned at the bartender. "It was a rough day."

"Happens to everyone."

"Not quite," Noah thought. He sat at the bar and got quite drunk and wondered how many guys kill their bosses or colleagues at work and stop for a drink on the way home Not many. However, it would make for an interesting social order, he thought. He imagined a planet amongst the infinite number of planets in the infinite expanse of the universe that is exactly like earth except in one way: people murder their bosses.

"Hi, honey, I'm home."

"How was your day?"

"I killed my boss. You remember Jeff Morgan. I cut off his head."

"Something had to give in that whole situation, sweetheart. You did what you had to do."

"Yeah."

"Can you start the BBQ?"

"I wouldn't mind a drink first."

"I'm sure it's been a hard day. You can pour me one too."

Noah drank himself into a stupor and still ordered another double vodka. Before filling the order the bartender asked if he was driving. Noah shook his head.

"Don't even have a licence. Got a carbon footprint

smaller than Janet Jackson's right nipple." Drunk guy talk.

The bartender poured his drink but didn't want to engage Noah in conversation. He seemed to be having a nice time talking to two women who looked like regulars. Noah looked at the women, who may at one time have been attractive but now were trying too hard to hold on to it. They had adopted the style of those who had slid to the bottom of middle age, and the style announced, "I'll fuck you in a second but it comes with a two-bedroom condo." This was a type who used to make him shudder. "There but for the grace of God sleeps Noah Douglas." But now, in his so-called new circumstance, they didn't seem like a bad bet. What if he simply turned right rather than left at the fork in the road and ended up being served dinner at the apartment of the blonde on the last stool? Lamb with small potatoes and a salad of radicchio and fennel, a movie with Meryl Streep and an invitation to stay the night. Things could be worse. He could disappear into that world and very likely no one would find him. He could forget about news regarding the McEwen incident because, he guessed, this woman didn't watch much news. He was certain that she would love trips

to Europe, and he might even be able to talk her into moving permanently to a Greek island. They could set up in a small village that had all the amenities: a butcher, a baker, a small market, a café for morning coffee and a number of bars for evening obliteration. And they could fuck. All he needed was the money. It was in the family and just out of arm's reach. But who knows. If he shook the family tree hard enough, something just might fall out. As the bartender poured him his "one last vodka," Noah leaned to him and nodding in the direction of the women, asked, "Are they regulars?"

"Pretty much."

"I think I recognize one from my junior high school but I'm too nervous to talk to her." Noah wanted to cover up whatever perverse intentions he might have revealed. However, the bartender seemed to be a veteran of excuses and evasions and paid no attention to Noah's comment.

"I'm finishing up now. Can you get the tab?"

"No problem. I've had enough anyway. Too much for me. You're a good bartender. I liked how you asked if I was driving. Very smart. Maybe I'll come back."

"It's a good place."

Noah finished his drink, paid with a generous tip and left the bar.

—•—

"Guilt." Noah typed the word on a blank Word document page. Then he typed, "The purgatory of self-loathing." He felt guilt for his lies and his jealousy and his competitiveness, but for some reason guilt was not a factor in his murder. McEwen was dead. Gone. His wife had hated him and wasn't suffering. They had had no children. McEwen had no siblings. For all Noah knew his parents were dead, and if they weren't he suspected that there hadn't been a great deal of love in the family. You don't turn out a son like Patrick McEwen with nurturing and love. Noah's absence of guilt interested him. Perhaps the evil feel no guilt. But how evil was he? Was evil something real, something scientifically quantifiable, or a religious idea with no objective truth? He wasn't Charlie Manson or Ted Bundy. He knew them only from the outside, from history and the news. From the outside they were the embodiment of evil, but from their inside looking out, they may feel no differently about their murders than Noah felt about his. Was there

an irreconcilable duality in every murder? He wasn't in the mood to go any further, so he drank his beer and vodka and fell asleep.

<center>—◦—</center>

Noah got a call from his bank that his account had gone beyond its $2,500 overdraft and could he take care of this. He called his local branch and asked for a meeting with the bank manager. She was about thirty-five, blonde, attractive and had no wedding or engagement ring. She wore a white spandex top under a short, tight baby blue cardigan with black, tight bell-bottom pants. She moved around the bank from her office to the tellers, signing transaction approvals and generally taking care of business in a calm, polite, no-nonsense way. What was wrong with this picture? Why no ring? Did she have no time for men as she moved up the bank's corporate ladder? Why this small bank? Was she just passing through on her way to the top? Or was she exactly what she looked like—attractive, unattached and lucky to have this kind of job? Noah pulled out the only currency he had left as she took notes in her small, unadorned office. His well-born middle name.

"My name is Noah Chandler Douglas. I don't think you have the middle name on your records. I don't like to use 'Chandler.' It has a strangely pretentious sound. My mother was a Chandler. Her family built one of the largest iron-mining industries in the country, starting back in the mid-1800s. Unfortunately, I didn't inherit their ruthless approach to the dollar, therefore I'm sitting here with you." He said all of this with an apologetic grin. "I'm a writer, and some writers, like myself, don't open their mail and have no clue about the state of their finances."

"What do you write?" she asked with genuine curiosity.

"Movies, TV and I'm in the middle of a novel right now."

"Any movies I have seen?"

"Oh, God, maybe when you were drunk." She laughed. She drank. This was all encouraging. Had Noah accidentally scored while he was doing nothing more than trying to worm his way out of a financial spot?

"What can we do about this overdraft?"

"I wouldn't bet a dime on my novel," he laughed with the right amount of self-deprecation to put her at ease. "But I just made a deal to write thirteen episodes

of a TV series, a political satire. I'm waiting for my first cheque. I feel so weird talking about money like this. 'Waiting for a cheque.' My ex-wife used to take care of all of this. I was like the child in the family. I must admit, in terms of money I don't spend a lot, but everyone has always had to come in behind me and clean up because I have never understood how to balance a bankbook." Noah shut up and sat back. He liked his description of himself as the child in the family. He thought that a certain type of woman likes to mother men, and this bank manager could be that type. Perhaps even a nurturing dominatrix, he thought.

"How much time do you need?"

"Two weeks tops. Is it possible to extend my overdraft by another $2,500? If you check your records, I've been at this branch for the last fifteen years."

Noah could sense that indecisiveness was not her style and the amount wasn't astronomical. Without a beat she smiled.

"Let me take care of it. I'll watch for your show."

"Do you have a card?"

She handed him her card.

They exchanged cordial goodbyes and Noah left wondering if she would sleep with him. But he put this

out of his mind when he calculated how many lies he would now have to juggle and the energy it would take.

———◦———

The arrest in the McEwen killing made the front page below the fold. The student had been charged with murder and was in jail pending a bail hearing. By noon Noah was dead drunk. He fell asleep on his couch and didn't wake up until the evening, when the phone rang. He couldn't tell what time it was when he answered and tried his best to sound wide awake. A cousin on his father's side of the family had just given birth to twins, and her mother was on the other end insisting that he come to a brunch in her honour. He was still too disoriented and hungover to come up with a quick lie that would get him off the hook so he accepted.

Noah hung up and looked at his watch. It was seven o'clock. He had no plans for the rest of the night or tomorrow or the day after. He usually felt depressed when he woke after sleeping all afternoon, and the stupidity of drinking early in the day multiplied the intensity. He couldn't tell whether he was hungry or not but knew that he had to re-establish some sched-

ule. He went down for a slice at the pizza joint across the street. "A slice and a drink for $5." That was all he could afford if he was going to keep himself in booze. The extension of his overdraft by $2,500 wasn't going to last long.

The pizza made him feel like drinking beer and the evening air was warm, so he forced himself into the shower then went down to the pub with the window bar, ordered a cold pint and a double vodka and watched the pedestrians pass. Hibernia wasn't around, and he was content to sit alone at his window seat and let the alcohol do its work. Two hours later he wandered back up to his apartment and fell asleep on the couch. He didn't wake until close to noon the next day. This cycle kept up for a few days until it dawned on him that he was now in hell, or at least as low as one could go on earth, and he was in some way living with it.

Noah remembered an incident with a Holocaust survivor when he was living in the college dorm in his first year. He had become friendly with a Jewish guy who had the room across the hall. The guy's father came to help him move out at the end of the year, and Noah lent a hand carrying the heavier stuff down to their van. It was a hot day and he and the father took a break and

cracked a couple of cans of Coke. The father, who was around sixty, had strong Steve Garvey forearms covered with white curly hair. He had the physique of one of those men who could survive almost anything but might drop dead from a heart attack without warning. On the inside of his left arm was a faded tattoo of six numbers. Noah was nineteen and a product of an Anglican private-school education. He had no idea what the tattoo meant. The father could see Noah looking at the tattoo and almost casually said, with a slight Middle European accent, "It's from Auschwitz." He took a drink from his Coke and continued. "It's hot in this place. I bet they turned off the air conditioning the last day of classes." There was something about the man's ease and his modern manner that allowed Noah to ask what he thought was a touchy question. He wanted to know if he could ask the man about the camp. He had heard about it for most of his life but had to confess that he knew nothing about it. He had certainly never met anyone who had survived it or been this close to someone who had lived through such a significant event. The father was more than willing to answer his questions, and their conversation went on for at least a half-hour as they drank two more Cokes and rested while Noah's

dorm-mate packed books and papers into cardboard
boxes. One comment from the father always stuck in
Noah's mind and he now recalled it. "At first you're
scared every minute because they can kill you whenever
they want," the father had said. "In the ovens, or for no
reason, they can take their gun and shoot you in the
head. Once I woke up to find the man who slept in the
same wooden bunk with me dead in the morning. He
was alive at night and dead in the morning. A dead body
lying there beside me. The months pass and—in my
case it was years—your brain does something. You stop
being afraid. You don't get brave. There was no bravery,
no heroes. These are human things. Remember, there
were no humans. The Nazis took that from us when we
arrived. You stop being afraid, no matter what goes on
around you. This is where you live, this is where you are
going to die and you get used to it."

Noah lay awake on his bed staring at the ceiling and
wondered if he would ever become used to it.

———◆———

He put on his one pair of khaki shorts and a faded
Lacoste polo shirt, took public transit as close as it could

get him and walked the rest of the way to his aunt's house deep in the city's original WASP neighbourhood. Everything here was over three million, one of his cousins said as he handed Noah a glass of sangria. They were standing in the backyard, where most of the guests had gathered. Noah took the horrible drink with pieces of fruit floating in it because the day was hot and he had already fortified himself with six ounces of vodka before leaving his apartment. The cousin who had given birth to the twins walked around the yard holding one in each arm like two riding trophies, showing them off to admiring family and friends. Noah and a young couple looked down at them and smiled. "They're very cute," Noah said. "You have two, I don't have any. Can I have one?" He got a bit of a laugh and wondered how hard they would have laughed had he said, "I didn't know you had *Siamese* twins."

Noah's aunt, the proud grandmother, approached and thanked him for coming. "What are you up to these days?" she asked with a smile as inviting as consommé soup at room temperature.

"There it was, like clockwork," he thought. "The family question."

"I'm writing."

"TV?" his aunt asked. She seemed to be slightly better informed than most of his relatives.

"No, a novel."

"That's wonderful. Really, a novel?"

"Yeah."

"Can I ask what it's about?"

"The Second World War. A lot of it's historical and I have to do a ton of research. But it's very educational."

"I can imagine it would be. Why don't you have a bite to eat?" She spotted two newly arrived guests and excused herself.

Noah finished off the disgustingly sweet sangria and headed to the bar situated under a giant maple in search of a gin and tonic. He had the bartender pour him a triple gin and moved to the food table, where he stuffed himself on cold poached salmon and potato salad. This was the first decent food he had eaten in days. He was sorry that he hadn't brought a backpack, because bottles of gin and Scotch were lined up on the grass next to the bar and he could easily have taken one or two. He moved back to the bar for another gin and tonic, and while the bartender poured it he found himself standing beside two men he didn't recognize who were discussing what they'd read in the papers about

the McEwen murder case. The men were in their mid-
to late thirties and sounded like lawyers. One of them
said that the accused was from a good family and that
they would likely get Martin Silverstein, the top crim-
inal lawyer in the city. From what they knew about the
case, they agreed that the prosecution had a strong case
and that Silverstein had lost his last three cases and that
his reputation was based more on self-promotion in the
media than on real talent. Had he been, Noah thought,
a mass or serial killer rather than a "one-shot wonder,"
these two would be high on his hit list. They were the
perfect demographic: self-satisfied, privileged, success-
ful and wrong. He was drunk and tempted to inter-
rupt their smug, self-congratulatory legal bullshit. "You
don't know what the fuck you're talking about. The stu-
dent didn't do it, I did it. And if you think the prosecu-
tion has a good case, you should go back to fucking law
school!" But instead Noah walked away, downed half of
his second triple gin and tonic and dropped into a lawn
chair beside a very old woman who was sitting it out on
life's bench.

"Nice day," he said to her.

"Isn't it," she said, as if that was her medically pre-
scribed verbal limit for the day.

He sat in silence with his drink and watched the guests in the yard and he was overcome with a strange feeling. Looking at the face of each adult, he could see only one thing, and that was their pain. Whether they were smiling or talking or sitting and saying nothing, that was all he saw. He wondered whether this was some kind of hallucination brought on by the gin he wasn't used to drinking. Gin, his mother used to say, made angry drunks. Maybe this was a related side effect. He couldn't discern the specific kind of pain, but there was pain in every face. He remembered a class in political science at university where the professor assigned *The Leopard* by di Lampedusa, about the rise and fall of an aristocratic Sicilian family. One character says to another that the Sicilian ruling class will never change because they think they are perfect. And the line from the book Noah had never forgotten was "Their vanity is stronger than their misery." He realized that he couldn't discern the individual nature of the pain in the faces in front of him because of *their* vanity. But it was there.

Noah began to feel sick from the heat and gin, and he suspected that the horrible sangria also had something to do with it. He was sweating through his shirt and nearly soaked. He pulled himself up, said "Ciao"

to the old bird next to him, found the new mother, again congratulated her on her two "beautiful children" and left.

Two or three blocks from the party but still deep in three-million-plus territory, he couldn't hold it in. He bent forward and vomited on the street. A guy washing his Lexus SUV stared at him as if he had just reduced the property values by twenty-five per cent. Noah was hoping SUV might make him pay and come after him with a rake and that a fight might break out and there would be blood, but the guy stood there horrified and disgusted. Noah smiled at him and held out his hands, palms up, with a shrug, as if to say that in the history of the universe since the big bang, this was a piss in the ocean. After a half-hour walk he arrived at a busy commercial thoroughfare and felt better for the salmon and potato salad he had left behind in the land of the blessed.

Back at his apartment, Noah felt insulated from everything. It was Sunday, the day of rest, so he felt no guilt when he turned on the golf and cracked a beer. Golf, more than anything he watched on TV, gave him comfort. When he looked at the fairways and rough on the great courses like Sawgrass and Augusta, he could remember the smell of the grass of the country-club

course where his parents belonged and where he played as a kid. Now, when he looked at TV close-ups of the players' shoes as they set up a putt, he could smell his father's golf shoes in his locker and the sweet ocour of talcum that the men used after eighteen holes and a shower. The smell of golf was the smell of privilege, and for a thirteen-year-old who knew nothing of death or defeat or loss, it was the smell of immortality.

When he woke up late the next morning, Noah realized that there was no reason for him to get up and go out into the world. He found this disturbing. He needed food and coffee and alcohol, but other than that he couldn't imagine what out there held any promise. He rolled over onto his back and thought how this state of being did have a positive side. No one expected anything of him. The only need beyond sustenance that could complicate things, and only because it involved another person, was sex.

Andrea Scott was easy enough, but the novelty had worn off, and novelty had always been a big part of Noah's sexual appetite. He had nothing to lose with a

shot at The Hobson Girl. His need to lap McEwen was no longer an issue, so the pressure was off. She was attractive, smart and young, and he wanted to know what she felt like. Wasn't that a healthy desire? Why struggle with "issues" beyond that? Why open up a political can of worms? Why not keep it simple and sexy and let what would happen happen? He emailed her and arranged to meet at the Starbucks in the lobby of the university's athletic centre.

———•—•———

When he arrived she was already sitting with a coffee and with her laptop open. They said hello and he got a coffee and sat down. "Work?"

"No. I'm trying to organize my CV. I have some job interviews this week."

"What are you looking for?"

"Waitress."

"I'm still waiting to hear from the producer about you. Did you read the outline I emailed you?"

"Yeah."

"And?"

"It seems interesting. I don't know much about that

kind of stuff, but it's a show I might watch even though we don't have a TV. I watch some stuff online."

"We?"

"My roommates and me."

"How many do you have?"

"Three. Two girls and two guys."

"Is that a good arrangement?"

"Yeah. Everyone's pretty cool."

Noah felt a distance open up between them as if he were on an ice floe that had broken free from a glacier. He had nothing to say and for some reason felt no energy to make something up or be witty or interesting But just as the silence approached discomfort, The Hobson Girl spoke up.

"I have something for you." She opened her backpack and pulled out a used manila folder with a few sheets of paper inside. She handed it to him. "It's a short story I wrote. When you mentioned *Crime and Punishment* in your lecture, I thought I should get it. I've read about two hundred pages. It inspired me to write that story. I don't know if 'inspired' is the right word— maybe it gave me the idea to write it." Noah started to leaf through the pages. "Don't read it here. It's too embarrassing and it's most likely horrible."

"I doubt that it's horrible."

"Yeah, well . . . I can't do that TV stuff. I thought about it. Thanks anyway."

"Will you go out for dinner?"

"I don't think so." She started to pack up her laptop. "I gave that to you because I thought your lecture was pretty insane. In an interesting way, I mean." She stood up. "Also, I'm twenty years old and way too young to have dinner with you, if you know what I mean. I have to go. It was nice meeting you." She offered her hand. Noah had been blown off by women before, but never someone this young and hot and with such grace. He shook her hand and said nothing. This time he didn't look at her ass as she walked out.

He read the story on his way home, walked into his apartment and immediately poured his beer and vodka medication. The story was well written and chilling. The principal character murders a colleague out of jealousy and believes that his act will free him from his jealous obsession. Noah downed the vodka and dropped onto his couch with his beer. Did she know?

Was she guessing? He couldn't figure it out. If she sus-
pected him, why let him know? How could she do that
and still feel safe? It didn't make sense. He relaxed as
the alcohol did its work, and began to lean toward the
most logical conclusion. She was an innocent who
couldn't imagine he would do it, or more precisely that
she did imagine it. He decided that her story was pure
fiction. Only one question remained. How does the
mind of a twenty-year-old girl work? This was some-
thing he would never know.

———◆———

The world outside Noah's apartment was now, more
than ever, a hostile place to be avoided. Even the phone
demanded explanations about his state of employment
and general existence. The TV producer called and
wanted to know what kind of progress he had made on
the scene they were supposed to present to the network.
Noah told him that his novel idea had sold as a script
deal and he was writing it for an L.A. company. He
explained to the producer, exaggerating the man's status
in the business, that "You have five or ten projects at dif-
ferent stages of development and production. I have one

career. If you were in my shoes you'd also take care of yourself first. This script deal is very important to me and I have to give it a hundred per cent." The explanation was, though a lie, and perhaps even a transparent one, accepted by the producer, because the truth was irrelevant unless there was real money on the line, and they both understood this.

———

Noah was now sleeping into the early afternoon every day, trying to bury as many conscious hours as he could before he started to drink. His decision to kill McEwen infected his every thought and many of his dreams. He felt that he was trying to escape it all down a river of rationalization that narrowed the farther he went, and the constriction was beginning to suffocate him. Every morning when he woke he found it harder to get his breath, to dress and shower and shave, to go out for his coffee and *New York Times*. Reading the paper, he found himself skipping world events and scanning much of the rest. The only place he found some comfort was in the sports section, where the stakes were limited to games he could never play and results that would never

touch him. He pulled for the favourites to win because, in some way, that kept the world on an even keel—predictability in the midst of chaos.

He had started drinking earlier each day and was conscious of its alcoholic implications, so he tried to stick to a more businesslike schedule that started at five with the happy hour at the pub downstairs. The once disparaged window bar was now his spot. Hibernia would show up from time to time, and they would drink together and discuss what they had seen on CNN. Noah turned down any invitation to move on to "Girls Girls Girls" later in the evening because it took too much energy. A sluggish inertia controlled him now more than any other drive. He was able to score a gram of coke now and then from Hibernia, but the cost was becoming prohibitive and coming down brought on flashes of McEwen's body slumped over his desk, spewing blood.

—•—

Noah lay on his bed and stared at the ceiling. It was two in the afternoon. The day before he had withdrawn cash from a bank machine and his balance showed that he

was getting to the bottom of his overdraft. He hadn't deposited the money he had promised his bank manager and had no clue where he was going to get it. "I have committed murder and have avoided Hopwood's net—how difficult could a robbery be?" he thought. He found it amusing that he was lying there planning a robbery. "That's what I'd call moving on in life," he said aloud. He ran through as many robberies as he could remember from the cop show he had written, but they were all tied to "relatable" sociological and psychological "issues" that had nothing to do with his circumstances. "Guy needs money" is not, after all, a hot storyline. Where were the straight-ahead robbery blueprints he could draw on? The reality of his situation quickly gave way and collapsed on top of him from its ceiling perch. He closed his eyes and was asleep in minutes.

He woke up at six-thirty and rolled out of bed. Without shaving or a shower, he went downstairs and crossed the street to a Lebanese takeout place that catered to students. He picked up a shawarma with hot sauce, which he ate on the street, then moved back down the block

and took his regular seat at the window bar with a pint and double vodka. The early evening air was pleasant and the street was crowded with pedestrians who passed close enough to give him the feeling that he was in the world. None of them had a clue that they were passing a cold-blooded killer.

Sitting at the window bar, Noah had abandoned any hope of a meaningful future. He accepted, at least intellectually, a life from day to day. He had no choice. If someone engaged him in conversation, he would now tend to go along, without judging them or their beliefs. He now seemed to accept people as equals, all in the same boat, all trying to make sense of an absurd world.

He checked his tab and realized that he could no longer afford the luxury of these daily bar bills. His energy was now going to go into keeping himself in booze, much like he remembered George Orwell's energy had gone into finding food in *Down and Out in Paris and London.* But there was no overriding liter-ary purpose in Noah's quest. Nor was there anything to learn, or sacrifice to make. There was only common drunkenness. He finished his drinks and returned to his apartment, where he discovered that he didn't have any beer left.

He checked his cash situation and had enough for
a taxi. He went back down to the street and stopped
one, got in and directed the driver to the closest liquor
store and asked him to wait. When the driver looked
back at him through his rearview mirror, Noah could
see a certain apprehension in his eyes. Noah's messy
hair and stubble didn't inspire confidence that he
would return to pay up, but he was out the door before
the driver could make a decision. He took a cart and
picked up a forty-ounce bottle of vodka and twelve
large cans of Czech beer. This was strictly a drinker's
load, he thought as he wheeled the cart to the cash.
No cautiously picked bottles of wine to go with a meat
or fish or aperitif to precede the meal. No single-malt
bottle of Scotch to be sipped during conversation. This
was a cart full of "fuck the world" booze. As he turned
out of an aisle of cheap local wines on his way to the
cash, Noah bumped into exactly the kind of person he
didn't want to meet looking like he looked and carry-
ing what he had in his cart. Tim Wentworth was an old
private-school classmate he had always hated. Went-
worth also pushed a cart, but his was full of what looked
like vintage wines. He wore a suede windbreaker, suit
pants and tasselled loafers. His salt-and-pepper grey

hair was perfectly styled and his wire-rimmed glasses were corporate.

"Noah?" he said with a questioning tone as if to say, "Is that you? You look like shit."

"Tim," Noah replied, revealing nothing. No interest. No question as to how Wentworth had changed, since he hadn't really. He had simply become the adult version of his high school asshole self.

"I hardly recognized you."

"It must be the accident," Noah said. He didn't know where this response came from. It was something instinctive he spat out to make sure that the conversation didn't take a path of Tim Wentworth's choosing.

"What?"

"I had a motorcycle accident while shooting in Spain. The actress on the bike with me was pretty banged up but okay. I broke my jaw, shoulder and four ribs. We were hit by a guy in a Ferrari and the insurance settlement was pretty fucking huge. I have to get going—I have to make martinis at a producer's birthday party." Noah indicated the forty-ounce bottle of vodka. "That should make about a dozen birdbaths, don't you think?"

"I guess," Wentworth said. He was unable to get a fix on Noah.

The conversation, as Noah had hoped, was changing course a bit too quickly for the ploddingly well-organized and obviously well-heeled Wentworth. This was coke speed and not sipping a Châteauneuf-du-Pape speed. The bottle caught Noah's eye from Wentworth's cart. Before Wentworth could respond to any of the lies, Noah reached out and touched his arm and, with a warm smile and a hint of sympathy, said, "You're looking older, but who isn't. Time is the most democratic of all laws. We're all treated equally. I'm late." He turned and pushed his cart to the first cashier and prayed that his debit card would go through. Wentworth had entered the next cash line and refused to even glance in Noah's direction. The last thing Noah needed was a rejected card that would force him to leave empty-handed and likely blow his cover. His card went through, and all he could think on the way to the waiting taxi was how deeply he despised that man.

———

Back home where so much could be flushed down the toilet with a long satisfying piss, Noah cracked a beer and poured a vodka on ice. He put the rest of the beer

into the fridge and the vodka into the freezer and sat down in front of CNN as if being a viewer fulfilled his obligations as an active citizen. He suspected that this notion was the symptom of a dying soul but pushed the idea out of his mind with a substantial gulp of vodka. The phone rang.

It was Andrea Scott. She wanted to know whether she could come over the next day. She was by now Noah's only contact with the outside world, and her voice reminded him of his mother's "I'm home!" when she got back from shopping.

Noah buzzed Andrea up and went to the door and let her in. She gave him a kiss, and then exhaled a breath of relief as if he had just rescued her from something. She dropped her purse where she always did, on a chair by the door, then emptied a large brown-paper shopping bag of groceries.

"You never have anything to eat. I worry about you."

"Are you kidding? I live on calorie road here. Sugar and fat in every imaginable form."

"This isn't exactly health food, but at least it's good.'

She unpacked prosciutto, Italian salami, a large jar of grilled Italian artichokes, a jar of antipasto, a jar of Italian tuna in olive oil, a Dijon mustard, four different cheeses, four different boxes of pasta from Italy, two large jars of tomato sauce also from Italy, two plastic containers of olives and a baguette.

There was something about Andrea Scott that Noah appreciated beyond the sex. She had a good sense of balance. She knew exactly how close to get to him without compromising this situation that worked well for both of them. She was sensible and sensitive and this made her appear oddly sad to Noah, because in mastering her universe she had eliminated something else. He didn't know what it was—those were subjects they didn't get into—but it was clear to him that she had left something behind when she made her deal with the world. Noah knew he wasn't going to provide what was missing. At best he was a place she could go and forget herself, and this made him feel good and needed in just the right measure. These thoughts about her today made her seem more sexy than usual, and he couldn't wait to crawl into bed with her.

She curled up to him. They held onto each other without talking for a number of minutes. Lying there,

Noah wondered if Andrea's unexpected call might be some kind of harbinger. He had never before taken seriously this kind of spiritual conjecture, but he now felt like a maximum security prisoner in the corporal world, paralyzed by his circumstance. So he decided to acknowledge the sign. He didn't know where it would take him, but at least it was an attempt to move.

"Can we talk for a second?" he asked.

"Of course."

"I have something unsettling to tell you. Don't worry, I don't have AIDS. This is nothing that can touch you. But when you hear it you may walk out of here and never come back, and I'd understand that. A university professor was killed a number of months ago with a machete. It was a pretty dramatic news story for several days, and the police eventually arrested a suspect. Do you know the story I'm talking about?"

"Yes. Vaguely. With kids, I don't like to follow morbid crime stories. I get too nervous about them, even though that's crazy."

"I can understand that." Noah hesitated. He wasn't sure how on earth she would take this. He hadn't even thought of her children and how she might react because of them.

"Are you going to continue?"

"Yes. You are the only person who will know this, and I hope I'm not dropping way more on you than I should. They arrested the wrong person. I killed him. I don't want to talk about why I did it. That's too complicated and perhaps not even the point. I'm not a dangerous person, and you have nothing to be afraid of."

She didn't pause. "Just fuck me," Andrea Scott said as she rolled over on top of him and kissed him deeply.

As they fucked more violently than ever before, Noah thought, This is *Belle de Jour*. This is life as art. And whatever Andrea Scott thought were her thoughts. They didn't exchange them.

They fell asleep for an hour, then Andrea got up and left as always and nothing of Noah's confession was mentioned.

——◆——

Noah got the call just before eight in the morning. This was his worst hour, the time when most productive people were getting up.

——◆——

He looked at the rack of doughnuts and couldn't decide
between the more adult chocolate cream and the Hawai-
ian, which had a cream filling, a frosted top and sprin-
kles. He ordered a medium coffee and a chocolate cream,
which, because of some weekly special, they rolled in
the Hawaiian sprinkles for no extra charge at the cus-
tomer's request, making it a chocolate Hawaiian cream.
Noah picked up the chocolate Hawaiian cream, or was
it the Hawaiian chocolate cream, and sat at the Arborite
table that was bolted to the tile floor. A few years ago this
place would have smelled of cigarette smoke and cleaning
chemicals, now it was just cleaning chemicals. He didn't
feel he had to open a laptop or a newspaper while sitting
here alone. In this place it was acceptable to sit with your
doughnut and coffee and stare at nothing in particular.
Noah had finished his coffee when a man of his age in a
polo shirt, jeans and expensive loafers walked in and dir-
ectly up to his table. Noah knew right away that this was
Andrea Scott's husband and was grateful that the table
was bolted to the floor because her husband approached
so quickly that Noah sensed his next move could have
been to grab the table and smash it over Noah's head.
This could kill him or cause brain damage that might
leave him drooling in a home for the rest of his life.

"Noah Douglas?"

"Yes."

"I'm Paul Wharton, Andrea's husband. I'll get a coffee."

He went to the counter and ordered a coffee, brought it back and sat down across from Noah, who felt slightly ridiculous with a half-eaten chocolate Hawaiian cream in his left hand. Noah was the guy Andrea wanted to fuck, but this childish choice of doughnuts made him feel almost pre-pubescent.

"My wife and I were having an argument about something that had nothing to do with you and in the middle of it, I guess to make a point, she said that she was having an affair with you. She didn't give me your number, only your name and what you do. TV?"

"Sometimes."

"I'm a partner at Hesseman, DiMarco, Blake, and our firm does some work for the owners of a couple of independent stations. I asked my secretary if she could track down your number. Andrea doesn't know I called you. She doesn't know we are meeting."

Noah said, "I really think this is something between you and her." He had no interest in explaining himself, but he didn't know what else Andrea Scott had revealed

so he had to be careful not to antagonize him.

"Think what you want."

It was clear that her husband had no intention of engaging Noah in a conversation or listening to what he had to say.

"We have three girls. We own a home and a summer cottage and the girls are all enrolled in private school. That is our world. That is what we call a family, and I won't let you or anything else wreck it."

This guy was like the *Titanic*, Noah thought. One of those people who, for his entire life, had believed he was unsinkable. Then out of nowhere he hit the iceberg, Noah Douglas.

"I don't want you to call or see my wife again. If you do, our next encounter won't be this civilized." He stood up and left his coffee untouched on the table. "I'm going to get a box of doughnuts for my girls. I'd appreciate it if you waited here until I'm gone." He went to the counter, ordered a half-dozen doughnuts and left.

Noah sat with his doughnut and thought that if he lived, even peripherally, within the "normal" world, a world that included people like Andrea Scott and her husband, he might react to this confrontation. He might try to explain himself or cover up or go head to head,

mano-a-mano, with this aggressive jerk, but he had fallen so far out of life's grinding gears that he had no conventional options left to play, or at least no interest in playing them. Sitting there in the toxic sterility of the doughnut shop Noah felt he had finally hit bottom and was overcome with a sensation he had never before experienced, as if the impact of his fall had cracked open a vault of unconsciousness and some buried part of him had come loose.

14

Writing

Noah sat at his laptop and let the first scene of the story in his head play out, then began to type:

It is 8:30 in the morning, July ninth, and I am lying in bed awake with my eyes closed. The birds are chirping outside my window, and I can tell that the sky is blue because I can make out the sun's reflection off the shiny painted windowsill through my eyelids. I think that birds chirp one way when it's sunny and a different way when it's cloudy. I'm sure I could look that up and find out if I'm right. I have been lying here like this for about an hour, thinking one thought. It is a thought I have never had before. I am thinking that I am twelve years old and I am completely alone in the world. I am lying in the same bed I have slept

in every day of my life, except when we have gone away on
vacation. I am lying in the same house I have lived in my
whole life. And I am thinking that I am completely alone
in the world and will most likely be alone until the day I
die. This thought doesn't scare me. It feels normal.

Noah sat back and read the few sentences he had
written. He wasn't sure what this was, but he could hear
a voice in it. And this he knew was good. He was in no
hurry. He finished his beer and fell asleep in front of
CNN. He woke up around one-thirty in the morning,
turned off the TV, went back to his laptop and read the
paragraph he had written earlier, then crawled into bed
and let the story continue to run as he fell asleep.

He woke up around noon, went directly to his lap-
top and started to write:

My father backs the vintage Jaguar out of the garage. He is
proud of the Jag and drives it only on summer weekends.
He and my mom are in the front. I am in the back. The
same thought is still on my mind, and it's kind of weird
that neither of them knows what I am thinking. I look at
each of them—the backs of my parents' heads, that is. I
realize that they are strangers. Then I think, "No, that's

not it. *They aren't the strangers, I am the stranger." That*
is the real thought. I am the stranger. The thought is def-
initely new to me, but it is also exciting. I do nothing to try
to stop it. I don't say, "Hey, everybody, yesterday I felt like
a member of the family. Yesterday I knew everybody here.
But not today." Sitting there with my new, private thought,
I feel like I have just opened up a great present, something
from a sporting-goods store, like a new all-leather Spalding
ball glove. I move the thought around in my head like I am
quietly working in the glove. I have never had this feeling
before, that you can move a thought around in your head.
But I have it with this thought, this morning. As we drive,
I wonder if a normal kid of twelve might start to feel scared
when a thought doesn't go away after getting up and going
to the bathroom and having breakfast and getting dressed.
It doesn't go away after arriving at my uncle's place, but I
don't feel any panic. My uncle and aunt and two cousins
have always felt different to me, so this new feeling about
them too is no big deal. My mom says they are different, so
naturally I feel they are different. None of them ever wear
jeans or regular sloppy clothes. They are always dressed in
clean, ironed stuff, even on a weekend in their backyard
by the river. This is my father's side of the family, and we
were never that close to his side because none of us liked

his father, my grandfather. We were taught not to like my grandfather by my mom because she believed he treated my father badly. But this morning what I think about my mom's ideas is irrelevant because I am now a stranger to her. This morning my aunt and uncle and cousins don't just feel not close; this morning they feel like people I have never met before and will most likely never see again.

The next morning I wake up to the chirping birds of another sunny day. The first thing that comes to mind is the "big" thought. I am still alone in the world.

Before I open my eyes, I sniff an unfamiliar smell. At first, I think my mom is cooking something new downstairs. She is a bit of an experimenter when it comes to cooking. But as the smell lingers I decide it's not a cooking smell. I push my nose into my sheets so I won't breathe it in, but there is also an unfamiliar smell to my sheets. They don't smell like my room, they have their own smell. I don't recognize that smell either. I decide to get up because I can't fall back to sleep. I go downstairs to the kitchen, where my mom is drinking coffee and eating toast and reading the paper. "What's that weird smell?" I ask her.

"There is no weird smell," she says. "I just made your father breakfast and he has left for the golf course. I have

shopping to do, and I want you to go up and make your
bed. There are fresh sheets in the laundry room. Do you
want to come with me?"

"What's that?" I say, pointing at her hand that was
holding the toast.

"Toast with cream cheese. Would you like some?"

"No, on your nails."

"Polish," she says without looking up from the paper,
as if that is the most natural thing in the world. But she
had never, as far as I could remember, worn nail polish
unless she was going out to a party at night.

"If you want to come, you'd better get a move on."

I decide not to go and head upstairs to the second-floor
laundry room with a washer and dryer and a folding table
where the sheets are piled. The room has a different soapy
smell than I am used to, and I figure my mom has changed
the detergent brand. On the shelf above the washer is a
box of soap I have never seen before. "That explains it," I
think. I pick up the sheets, a contoured bottom and a flat
top sheet and a pillowcase. They don't smell like anything
I have smelled in our house before, except maybe the smell
of my bed when I woke up this morning.

I go back down to the kitchen and ask my mom why
she is using new soap. She says it is the same laundry soap

she has always used and asks me why I am so interested in soap. "It smells different," I say.

"Well, I haven't changed our brand in years and I don't think the company has been playing around with their odour because it smells the same to me. Maybe it's your nose. Maybe you are getting a cold."

"In the summer?" I ask. "Is that possible?"

"Of course," she says. "You can get a cold at any time of year. Now, you haven't had a thing to eat and I want you to have something before you go out."

"Go out where," I think. If I have a regular thing to do—let me say that again—if I had a regular thing to do, as the old me, I have forgotten what it is. And if I ask my mom what it is, she might think that I am weird, especially if it is a regular thing. I figure I have to do this one step at a time and see what happens. "What's to eat?"

"Whatever you want."

Now this is a problem, because the list of whatever I want would most likely be short since I'm twelve years old and hate almost everything, but I must have a list and I have no idea what it is. This problem gives me a scary feeling. I am beginning not to recognize myself. Yesterday I thought that was pretty cool, but now not even knowing what kind of food I like is kind of crazy. "How about my

favourite?" I say. I think that is the best thing to say since my mom would know exactly what that is.

"What favourite?"

"I don't care. You choose."

"You're behaving very oddly today, Noah."

"Noah?" I say to myself. "My name is Noah?" Either I have forgotten it or I am now living in a parallel universe. I had seen a show something like this on TV, but I can't remember what happens.

"Jeez. 'Noah,' that's a name a twelve-year-old is going to have a problem with," I think.

"Where's your ark, Noah?"

"Do you get to see all the animals on the ark fuck, Noah?"

"What kind of wimp name is 'Noah,' Noah?"

"Hey, Noah, you plugged the toilet with too much bum wad, now we're gonna have a flood for forty days and forty nights, Noah!"

"How about pancakes?" I say.

"I'm not making pancakes at this hour of the morning. I have to get going."

"Toast?"

"With?"

"Whatever." That is all she needs and she is off preparing toast and juice and milk and peanut butter and

jam and everything is fine. While I watch her, she starts to look more like someone we have hired to make breakfast than like a mother.

"Would you like some yogurt?" my mom asks.

"Yogurt?" I'm not sure because I have no memory of ever eating yogurt. "Sure. Not too much."

"It's strawberry, your favourite."

Finally some information on what I like and don't like.

"Okay," I say and start to eat while my mom clears the table and puts dishes into the dishwasher.

"If I was suddenly real old, like twenty-one, and walking down the street, do you think you'd recognize me?"

"Of course," she says.

"How do you know?"

"Because you're my baby."

"I wouldn't be a baby at twenty-one."

"To me you would."

"Really?"

"Yes, really."

"What if one morning I woke up and you didn't recognize me, like something weird had happened to me in the middle of the night and I didn't look like me and you came in to wake me up and there was a different-looking person in my bed?"

"I'd know it was you in disguise. Mothers always know their children."

"But what if I said I'm not your son?"

"I'd still recognize you."

"No matter what I looked like? What if I looked like a horse?"

"I love horses and I'd put a saddle on you and ride you off into the sunset."

"And what if I bucked you off and ran away and you never saw me again?"

"Then I'd be very unhappy for the rest of my life."

"Well, I'm not a horse so you don't have to worry about that."

"Good."

"But I want to tell you something."

"I have to take a shower. I'm picking up Mrs. Graham to go shopping." His mother went into the other room.

"You don't look like my mother anymore."

"Put your dishes in the sink when you're finished," she yelled back as she hurried up the stairs to change.

15

Lost and Won

Noah poured himself a glass of vodka and stood under a hot shower while the first satisfying buzz from the drink kicked in. He shaved and dressed and dug through a drawer for the memory stick he used to transport script drafts from his laptop at home to the cop show's production secretary. He erased everything on it, then used it to back up the story he had started to write and put it into his pocket. He phoned Hopwood and asked if they could meet at Buena Bean for a coffee and said that he had some information that might influence the case against the student in the McEwen killing.

—◂•▸—

They met an hour later and both ordered cappuccinos. When Hopwood joked that his department doesn't reimburse them for this kind of expense, Noah picked up the tab and they sat down. After a few pleasantries about the weather and the crumbling economy, Noah took the memory stick from his pocket and put it on the table.

"I'll make you a deal. I'll tell you what I know about the case if you ensure that I will be able to keep this, and that when I'm finished we walk out of here together like two normal people who have just stopped for a coffee."

Hopwood was an old pro and knew how to go along when he had nothing to lose. He sipped his coffee. "I don't have a problem with any of that."

"I killed McEwen. Your student had nothing to do with it."

Hopwood showed no surprise and again sipped his coffee.

Noah wondered if Hopwood was consciously playing it cool or if this was the real guy.

Noah decided that whatever act Hopwood was playing it was part of his job. His act wouldn't get him more money or more respect; it was just a tool of the trade and he chose the cool tool rather than the hammer, and Noah liked him for it.

"Can I ask why you did it?"

"Why I killed him, or why I confessed?"

"Both. Either. It's up to you."

"I killed him because he was an arrogant, selfish, phony prick."

"That was the only reason?"

"Yes."

Hopwood grinned and sipped his coffee. "That explanation just might give you a shot at an insanity plea."

"Unfortunately, it's one of the sanest things I've ever said."

"And the reason for your confession?"

"I discovered that the act wasn't complete without the confession. I think we should go. Did you drive?"

"Yeah."

Noah put the memory stick into his pocket and they got up and left. Hopwood kept his word. There were no handcuffs or any other police procedures. As they stepped outside, Noah bumped into a writer he had worked with on the TV cop show.

"Noah, how are you doing?"

"Good, good, and you?"

"I quit the show at the end of last season because I had a half-hour pilot picked up, a kids' show but I think

it's pretty good. They can be a fucking cash cow if they connect. What are you up to?"

"Oh, sorry. This is Detective Hopwood from the Homicide Squad, 52 Division. This is Howard Frank. We worked together." The writer and Hopwood exchanged a short greeting as Noah continued in a relaxed and sociable manner. "You remember the professor who was killed with a machete."

"Yeah, crazy."

"I did it. I just confessed, and I guess we're off to the police station." He turned to Hopwood. "Am I right?"

"Yes."

Noah turned back to the writer. "I think it would be disingenuous of me to say, 'Let's get together for a coffee some time.'"

Noah and Hopwood left the writer standing there, clearly not sure whether or not he had been had, as they crossed the street to Hopwood's car.

"You liked that," Hopwood said.

"Of course. How many times in life does an opportunity like that come up?"

They approached the drab detective sedan.

"Where are you guys going to find cars this ugly when Detroit stops making these?"

"It won't be easy."

"Front or back?"

"Front."

They got in. As they drove away in silence, Noah thought that no one would ever again ask him what he was up to.

Noah's conviction was front-page news. The gruesome and inexplicable nature of his crime had the TV pundits and columnists swarming like piranhas. Noah's only public statement was that he had committed this heinous act because his victim was a "jerk." He used the word "asshole," but most of the media who gorged themselves on the bloodthirsty details of the "slaughter" were loath to use this obscenity. And this left the question wide open. Why had he done it? Why had he confessed when it looked like he might never be caught? How could someone from his background commit this act? The "experts" had the answers, each with his or her own narrative, while life's ambiguities were left behind, the skeletal remains of the feeding frenzy.

Noah dressed for sentencing in his good suit, a kerchief in his breast pocket, school tie and Oxford-cloth white button-down shirt. When he stood to make his final statement in the stuffy courtroom, not a single drop of sweat dribbled down his side. "I doubt that you are able to understand my reasons for my actions since I do not fully understand them myself," he said to the judge. "The victim is dead, and whatever those reasons may have been are now irrelevant. The only certainty I can see in this horrific act is that there is life and there is death and these are irreconcilable." That was it. Noah was cuffed and taken away.